IMAGES
of America

CHICAGO'S
PILSEN NEIGHBORHOOD

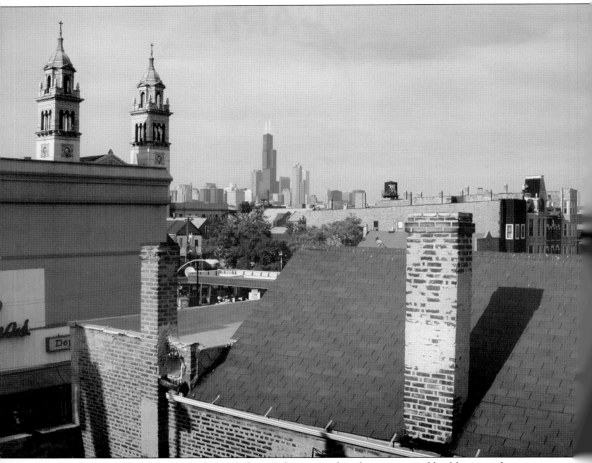

This photograph is a view of Pilsen's skyline. It features a church, commercial buildings, and cottages—three elements that make up the neighborhood landscape. (Courtesy of Antonio Perez.)

ON THE COVER: In 1962, a local resident of Pilsen photographed this parade headed west on Eighteenth Street where it crosses Blue Island Avenue. This intersection has been a stage for many political, religious, and cultural events in Pilsen's history. It is also a crossroad of commerce for the neighborhood. (Photograph by Adalberto Barrios.)

IMAGES
of America

CHICAGO'S
PILSEN NEIGHBORHOOD

Peter N. Pero
Foreword by Carlos Tortolero

ARCADIA
PUBLISHING

Published by Arcadia Publishing
Charleston, South Carolina

Printed in the United States of America

Library of Congress Control Number: 2010939732

For all general information, please contact Arcadia Publishing:
Telephone 843-853-2070
Fax 843-853-0044
E-mail sales@arcadiapublishing.com
For customer service and orders:
Toll-Free 1-888-313-2665

Visit us on the Internet at www.arcadiapublishing.com

*This book is dedicated to all the ethnic groups who settled in
Pilsen during the past 150 years; their story is your story.*

CONTENTS

ACKNOWLEDGMENTS

I wish to give credit to many people who assisted with this book. The first is Dr. Byung-In Seo, whose faithful support and sharp editing made this book a reality. I am also grateful to Melissa Basilone and John Pearson from Arcadia Publishing. Although the company has produced more than 6,000 books on local history, John and Melissa believed there was still room for a book on Pilsen.

The single greatest contributor of personal photographs to this book was Aurelio Barrios, who carries on a long family tradition of documenting the history of Pilsen with a camera. His father, Adalberto, began photographing Pilsen in the 1950s and left more than 5,000 images to posterity. Luckily Aurelio brought these rare photographs to my attention, and they have shaped every chapter.

I am proud to feature the photographs of Antonio Perez, renowned for his photographs in the *Chicago Tribune* and *Exito* newspapers. Perez has mentored Heriberto Quiroz, a young college artist who contributed photographs to this book based on events that happened a few blocks from his home in Pilsen.

Cathy Smith was my graphic advisor and tech wizard. Management Systems organization helped produce funding for photograph permissions and materials.

Carlos Tortolero provided access to the Mexican Chicago Photograph Collection at the National Mexican Museum of Art (NMMA) and wrote the inspirational foreword. Along with the NMMA, I thank Rita Jirasek, author and authority on Mexican Chicago.

As president of the Czech and Slovak American Genealogy Society of Illinois, Paul Nemecek was an essential resource for this book. He reviewed my manuscript with the discerning eye of a historian and archivist. Cary Mentzer opened the doors of the Czech Heritage Museum in Oak Brook to artifacts that helped me develop this book.

At St. Pius Church, Fr. Charles Dahm and Eric Schwister were great supporters. At St. Adalbert's Church, Richard Olchesky contributed rare photographs. Fr. Jim Collins at St. Procopius Church supplied photographs and personal research. Adam DeFault, the school principal at St. Procopius, gave support and historical testimony. Dan Pogorzelski was my resource on Polish Pilsen and his own Arcadia book, *Portage Park*, was an inspiration.

There were many others who generously opened their scrapbooks. Juan Manuel Giron contributed photographs and tales about his father's pioneering bookstore in Pilsen. Also students from Benito Juarez Community Academy proved they were not too timid to strike a pose for this book.

Finally, I must thank the hundreds of photographers who captured history through their camera lenses. Without their pictures, I could not create this photographic history of Pilsen.

FOREWORD

It is an old cliché, but Chicago really is a city of neighborhoods, and Pilsen is the quintessential Chicago neighborhood. From its inception, Pilsen has always been a "port of entry" for immigrants, a working-class community, and a center of community activism. Although Pilsen has changed culturally through the years, it has always remained true to its immigrant, working-class, and activist roots.

It is no easy task to tackle the history of Pilsen, but author Peter Pero has done an admirable job in putting together this book. The wonderful photographs here perfectly document the hopes and struggles of the different groups that have lived in Pilsen.

It is very appropriate that Pero, a teacher at Pilsen's Benito Juarez High School, be the writer of this historical book on Pilsen. Juarez High School is the perfect symbol of Pilsen. During the 1970s, parents (overwhelmingly Mexican) were disillusioned with the Chicago Public School System's failure to provide quality facilities for their students, and they took matters into their own hands. After years of protest and fighting a battle that few people believed they could win, they prevailed. In 1977, the newly built Benito Juarez High School opened. The struggle to build Benito Juarez High School clearly illustrates Pilsen's reputation as a center for community activism since its founding.

Today Pilsen has such nationally recognized nonprofit organizations as El Valor, which works with individuals who have disabilities; Mujeres Latinos en Acción, a leader in dealing with women's issues such as domestic violence; El Progreso Latino, which advocates for immigrant rights; El Alivio Medical Center, a pacesetter in community health issues; Pilsen Resurrection, which specializes in community building, especially housing; and the National Museum of Mexican Art, the nation's foremost Latino arts institution.

Obviously the people of Pilsen want the best for their community. This belief has personified the Pilsen community. In earlier years, residents were also very involved in other vital social issues such as workers' rights.

As someone who grew up a mile away from Pilsen, I can remember coming with my family to "La Dieciocho" (Eighteenth Street, Pilsen's main thoroughfare) to stockpile Mexican groceries. I was always awed by the vitality of this vibrant community.

Now 50 years later, I still find Pilsen an amazingly dynamic neighborhood and a place where people can walk down the street on an errand and be stopped several times by friends.

Let me conclude by saying . . . *que viva* Pilsen!

—Carlos Tortolero
Founder and President, National Museum of Mexican Art

INTRODUCTION

This book is about a piece of ground less than two square miles in size, but out of this compact community came poignant experiences related to work, worship, family unity, community pride, artistic expression, continuity, and change. This is the story of Pilsen.

The plan of Chicago is largely a grid set upon the prairie, but the area of Pilsen is shaped by geographic confluence and mechanical engineering. A canal, a river bend, a plank road, an interstate highway, a railroad viaduct—these transit arteries both enriched and deformed Pilsen.

The area's first known European visitors were Jacques Marquette and Louis Joliet, who arrived in 1673. Marquette was a Jesuit priest with a zeal for converting souls. His partner Joliet had a yearning to explore. On discovering that the South Branch of the Chicago River was impassable in winter due to ice, they portaged their canoes and camped for the season at a spot where today the Damen Avenue Bridge meets the Chicago River. This first encampment left a historic footprint on Pilsen.

Two centuries later, tens of thousands of immigrants would follow in Marquette's and Joliet's footsteps in coming to the area. Bohemians, Lithuanians, Slovaks, Germans, Croats, Irish, Poles, and Mexicans migrated to Pilsen primarily for jobs and low-cost housing. With the constant addition and subtraction of residents, the old frame and brick buildings in the neighborhood expanded and contracted too. This has been a trend in Pilsen for more than 150 years.

Pilsen is all about work. A century ago, there were beer breweries and grain silos to support them. Residents held jobs as garment workers, lumber shovers, millwrights, meat cutters, and industrial workers of all kinds. Today residents are more likely to find work as truck drivers, beauticians, auto mechanics, or food service workers. Many more laborers leave Pilsen to commute to jobs in Chicago's Loop or to the far-flung suburbs.

Although jobs are what Pilsen is about, residents take time for education as well. There are 13 public schools, five parochial schools, and a community college in the neighborhood. These institutions have provided generations of immigrants with the hope and skills for self- improvement.

Pilsen is a community of religious energy. Emigration from a distant country to an American metropolis like Chicago is an experience that requires faith, hope, and a few prayers. For this reason, Pilsen is crowded with churches; more than 20 houses of worship exist in this community.

People in Pilsen know about adversity. There are poverty, drug problems, street violence, and broken homes. Block for block, however, Pilsen is a community with more self-help organizations than in most neighborhoods of Chicago. The residents know how to fight to preserve the integrity and character of the community. Homegrown organizations like the Pilsen Neighbors Council, Mujeres Latinas en Accion, the Resurrection Project, and Gads Hill Center are a few examples of the local community coming together.

Pilsen is a blue-collar neighborhood with a vigorous work ethic. Nevertheless, the residents make time for celebration and produce indigenous art forms that attract national attention: folkloric dance, music, parades, and festivals that change with the seasons. A formidable mural movement

has put Pilsen on the national arts map. Indeed, this small community of nearly 45,000 people is home to a national art museum.

Sociologists have called the historic march of immigrants through Pilsen a prime example of ethnic succession, but this book presents Pilsen as a community of ethnic success.

Carl Sandburg, a poet laureate of Illinois, won three Pulitzer Prizes in his lifetime. His poetry evoked the sights and sounds of Chicago. In "Blue Island Intersection" from *Smoke and Steel*, Sandburg described the city's traffic and the Blue Island Avenue trolley that cut a swath through Pilsen:

> Six street ends come together here.
> They feed people and wagons into the center.
> In and out all day horses with thoughts of nose-bags,
> Men with shovels, women with baskets and baby buggies.
> Six ends of streets and no sleep for them all day.
> The people and wagons come and go, out and in.
> Triangles of banks and drug stores watch.
> The policemen whistle, the trolley cars bump:
> Wheels, wheels, feet, feet, all day.

Map of Pilsen

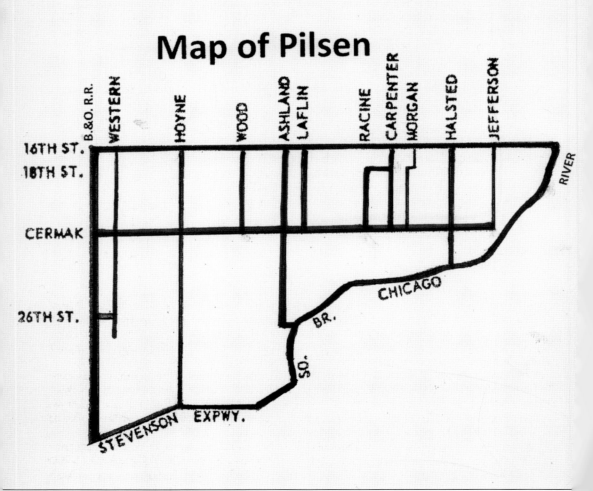

This map of Pilsen illustrates how both geography and human engineering have defined the borders of the neighborhood. (Courtesy of the Chicago Fact Book Consortium and B. Seo.)

One

BORN OUT OF INDUSTRY

From the mid-1800s to the present, industry and commerce determined the boundaries of Pilsen. Vaulted railroad tracks along Sixteenth Street defined the northern border of the community. The Western Avenue border included a cattle stockyard. The south branch of the Chicago River contained barges delivering coal and iron. Finally, Canal Street at the eastern edge of Pilsen was a hub for wagons transporting goods from Lake Michigan freighters.

Plank roads were the commercial lifelines for Pilsen in the 1800s. Blue Island, Ogden, and Archer Avenues were the major arteries that pushed "blood" through the commercial body of Pilsen. Along these streets, manufactured goods were carried out of Pilsen and raw materials brought into the area. Toolmakers, millers, tanners, and other Pilsen tradesmen were able to produce value-added goods for a hungry Midwestern market.

Today new veins of transit follow the routes where horse-drawn wagons and canal boats once travelled. Interstate 55 now parallels the old river canal through Pilsen. Metra interurban trains run parallel to the freight trains along Sixteenth Street. The Dan Ryan Expressway cuts a swath through East Pilsen, close to where wagon and riverboat traffic once existed.

More than a century ago, Pilsen guaranteed jobs for newcomers. Immigrants with strong backs and ready hands could find plenty of work as lumber shovers unloading canal boats from Michigan and Wisconsin. Raw materials were hauled by horse-drawn wagons or motor transit. All this economic activity meant that housing and ancillary services were needed to help immigrant families settle in the Near Westside of Chicago. As the area matured, large-scale manufacturing appeared in Pilsen. Tractors, beer, and clothing were some of the products produced in the community. The garment industry was a sector where men, women, and children could find plenty of jobs in the industrial lofts of East Pilsen.

Today the original trades that gave birth to Pilsen have disappeared. In their places are new businesses related to food production, trucking, restaurant work, and a nascent tourist industry. Pilsen is still hemmed in by a canal, a river, and a railroad, but its workers have branched out into brave new worlds of the Chicago economy.

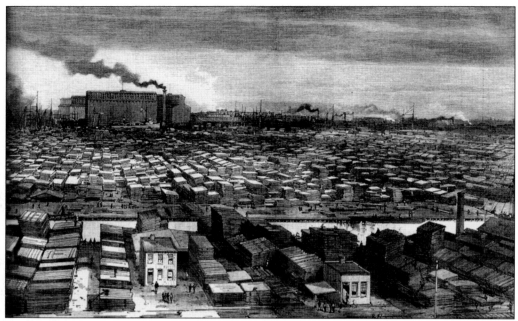

Lumber was a cash crop for Pilsen. Where the Chicago River shaped the southwest border of Pilsen, mountains of lumber from the Great Lakes region were stored and processed. During the mid- to late 1800s, the Pilsen Yards were one of the largest lumber distribution centers in the world. (Courtesy of William Adelman.)

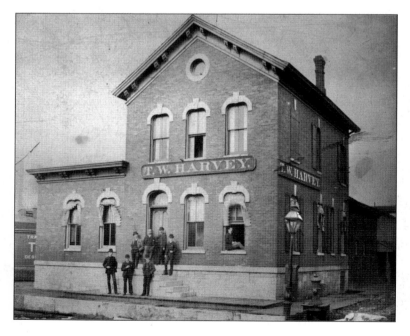

Jobs literally grew on trees in Pilsen's pioneering days. From the lumber shovers, who loaded river barges, to city carpenters and retailers of wood, the area economy thrived on lumber. This photograph shows the Harvey Lumber Company at Twenty-Second and Morgan Streets around 1900. (Courtesy of the Chicago Public Library, Special Collections and Preservation, Lo1-7.)

A profitable Pilsen industry was beer production. Over time, four large breweries were based in the community. One was the Atlas Brewing Company at 2100 South Blue Island Avenue. Shown here in 1915, Atlas made a popular brew called Peptomalt. This advertisement is printed mostly in Czech. (Courtesy of the Czech Heritage Museum.)

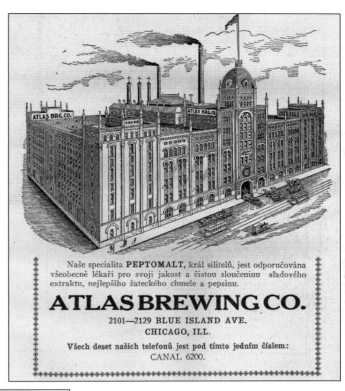

Naše specialita **PEPTOMALT**, král sílitelů, jest odporučována všeobecně lékaři pro svoji jakost a čistou sloučeninu sladového extraktu, nejlepšího žateckého chmele a pepsinu.

ATLAS BREWING CO.

2101—2129 BLUE ISLAND AVE.
CHICAGO, ILL.

Všech deset našich telefonů jest pod tímto jedním číslem:
CANAL 6200.

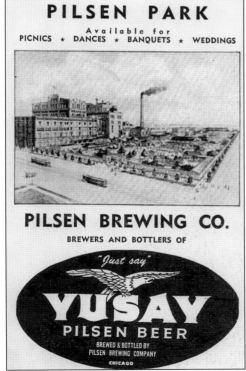

The Pilsen Brewing Company did more than just bottle beer. It had a vision for attracting customers much like Walt Disney did. The manufacturing company offered a beer garden with pavilions for picnics. Dances were frequently held in the "pleasure garden" until the brewery closed in 1963. The complex was so large that it was located west of Pilsen, in Lawndale, where land was more plentiful. In keeping with the Czech tradition of pilsner brewing, the company produced a popular brand called Yusay Beer. (Courtesy of the Czech Heritage Museum.)

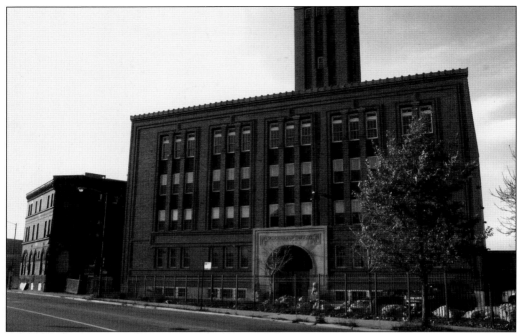

The Peter Schoenhofen Company in East Pilsen was one of the oldest breweries in Chicago. It was established in 1860 and became an official Chicago Landmark a century later in 1960. The well-preserved main building is an outstanding example of Prairie-style industrial architecture. The old stables and brew house were torn down as newer warehousing was built on the brewery site. (Photograph by P. N. Pero.)

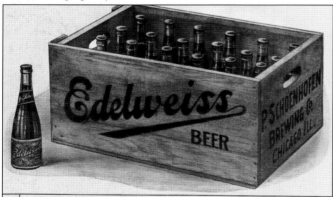

Schoenhofen's best-selling brand was Edelweiss Beer. Edelweiss is a well-known rural flower in Germany, and the Edelweiss beer label was popular in Chicago taverns. (Courtesy of the Czech Heritage Museum.)

This photograph focuses on the plant administration building on Eighteenth Street at Canalport Avenue. Schoenhofen adorned the facade with a bust of himself in a Roman-style toga along with a beard. Vandals stole the bust in the 1990s from a precarious position on top of the building. (Courtesy of University of Illinois at Chicago [UIC] Special Collections and University Archives.)

For many years, the Schoenhofen factory was shuttered and deteriorating. Today investors have restored the elegant architecture and have plans for using the brewery for offices and residences. (Photograph by P. N. Pero.)

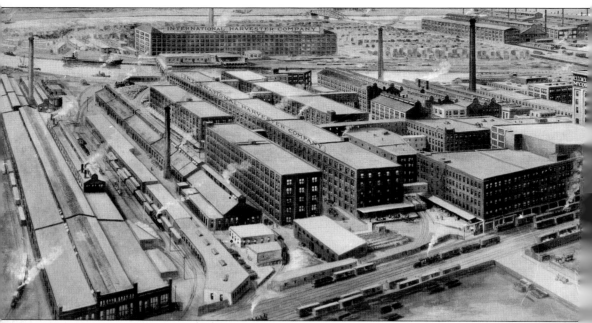

The McCormick Reaper Company was the largest employer in Pilsen at the beginning of the 20th century. It occupied acres of space at the junction of Blue Island and Western Avenues. At

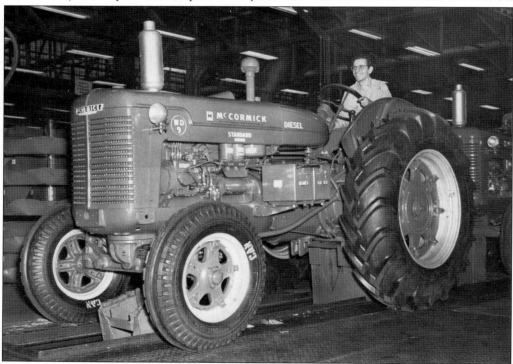

The core industry of Harvester International was the production of farm equipment. Sophisticated tractors and reapers for the harvesting of corn and wheat made the Pilsen plant a vital industry for American and world farm productivity. (Courtesy of Chicago History Museum, i61402.)

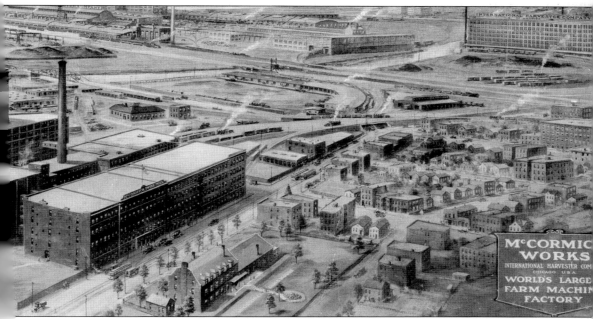

McCORMIC
WORKS
INTERNATIONAL HARVESTER COM
CHICAGO, U.S.A.
WORLD'S LARGE
FARM MACHIN
FACTORY

the time of this photograph, it was the largest farm machinery producer in the world. The factory complex was truly a small city within the city. (Courtesy of Chicago History Museum, i5128.)

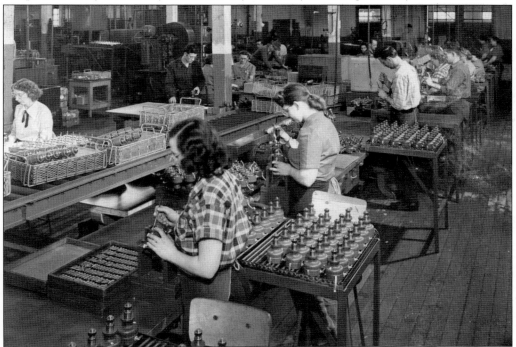

The plant implemented a progressive policy of hiring thousands of women and other minorities for the assembly line pictured here in 1952. By the 1960s, many of the jobs were sent to suburban Chicago, and by 1970 the International Harvester Pilsen plant was closed forever. (Courtesy of Chicago History Museum, i61401.)

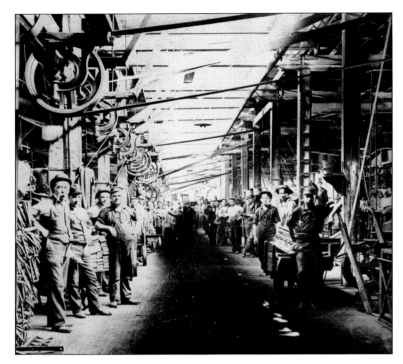

In 1868, the McCormick assembly line was producing about 10,000 agricultural reapers per year. They were sold to American farmers and exported to other countries as well. By 1903, the factory was firmly established in Pilsen, but this industrial conglomerate changed its name to the International Harvester Company. (Courtesy of the Illinois Labor History Society.)

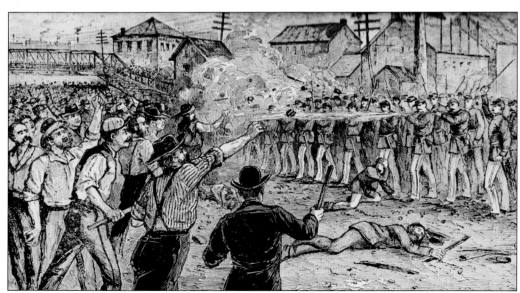

During the 1870s, America was experiencing an economic recession, and railroad workers had their wages cut twice in one year. This caused a rail strike from coast to coast, and Pilsen was at the center of it at a major junction for the Baltimore and Ohio Railroad. (Courtesy of William Adelman.)

According to Illinois labor historian William Adelman, the Bohemian, Irish, and Polish workers in Pilsen were the backbone of the strike: "Blacksmiths, bakers, stockyard workers, barbers and railroad workers stood up to the Illinois State Militia." (Courtesy of William Adelman.)

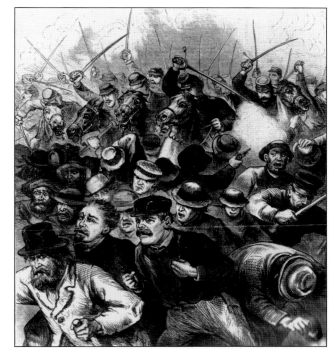

During several days of street violence, 30 immigrants were killed—two children— and about 100 workers wounded. There were no soldier deaths, but about 60 were wounded. The bloodiest fighting was at Sixteenth and Halsted Streets. Today no marker commemorates one of the biggest street battles in U.S. labor history. (Courtesy of William Adelman.)

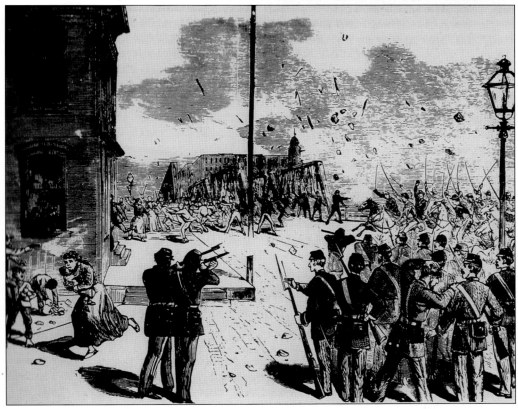

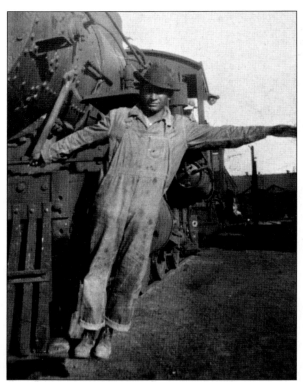

A decade after the great railroad strike, train arteries in Pilsen were open for business from Western Avenue to the terminal yards at Wells Street. The Chicago, Burlington and Quincy Railroad was another line that cut an east-west corridor through Pilsen. (Courtesy of NMMA, Mexican Chicago Archives.)

Perishable foods could be loaded quickly from refrigerated freight cars along the Sixteenth Street viaduct into this massive cold storage warehouse in Pilsen. Today these industrial storage lockers and refrigeration rooms have been converted to pricey condominiums. (Courtesy of UIC, Special Collections and University Archives.)

A common source of work for immigrant men, women, and children was in the needle trades. Garment shops were often located in loft buildings on Pilsen's east side. (Courtesy of Unite Here Labor Union.)

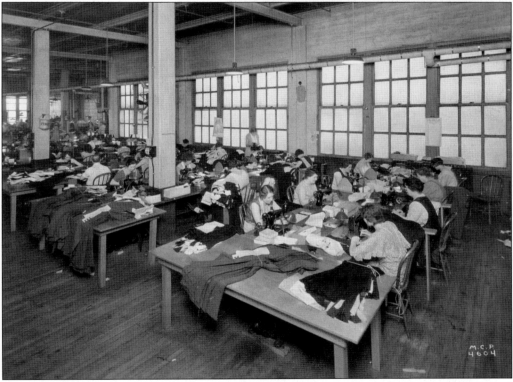

In 1910, workers for the Hart Schaffner and Marx Company went on strike for better hours and working conditions. Sixteen women in a sweatshop at 1922 South Halsted Street in East Pilsen were among the first to walk out on strike. By the end of the week, more than 2,000 garment workers followed the lead of these seamstresses to join the picket line across Chicago. This historic labor event unified Czechs, Jews, Italians, and other workers who could barely understand each other's languages. (Courtesy of Illinois Labor History Society.)

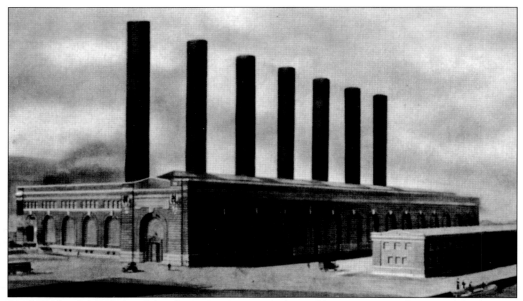

In 1907, the Commonwealth Edison Company was formed by Samuel Insull to capitalize on the huge demand for electric power in a growing Chicago metropolis. Through an exclusive franchise with the city, the Fisk Power Station generated 100,000 kilowatts of power to homes, businesses, and city streetcar lines. In 1912, Thomas Edison made a personal visit to this giant plant on Carpenter Street in Pilsen. (Courtesy of the Exelon Corporation.)

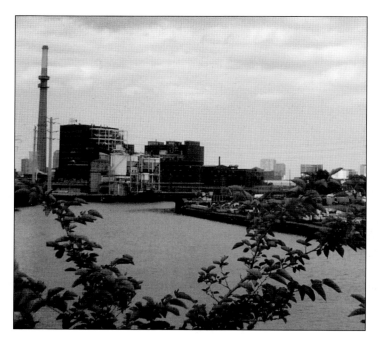

Today the old Commonwealth plant is called the Midwest Generation Station in partnership with the Exelon conglomerate. Midwest Generation produces electric energy in Illinois through coal, gas, oil, and nuclear sources. The coal-burning stacks at the Fisk Power Station are more than 100 years old and cause alarm to some environmentalists who worry about air pollution in Pilsen. (Photograph by P. N. Pero.)

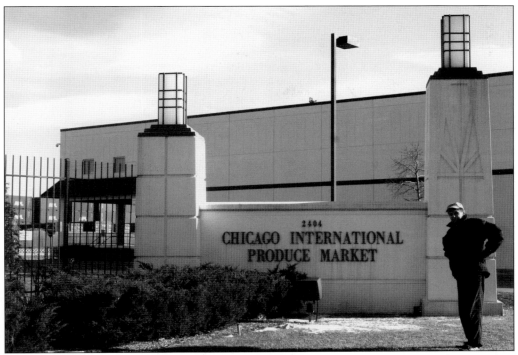

One of Pilsen's new and successful industrial operations is the International Produce Market, which was established in 2003. When Chicago outgrew its old fruit and vegetable market created in the 1920s just south of Little Italy, the new market in Pilsen offered more loading docks, online inventory, international produce, and organic foods. (Photograph by B. Seo.)

The new produce market, a few blocks from the Stevenson Expressway at Damen Avenue, is a bees nest of traffic. As early as 5:00 a.m., trucks hustle off to grocers and restaurateurs who depend on freshness and same-day delivery. (Photograph by P. N. Pero.)

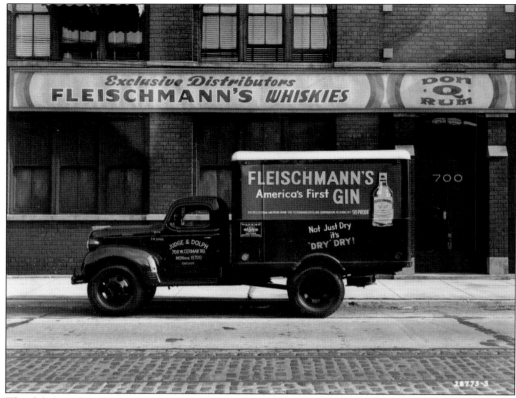

The delivery, distribution, and warehousing of goods has been the lifeblood of the Pilsen economy. The Judge and Doph Company on Cermak Road is one example. It distributed rum, whiskey, and gin to outlets in Chicago. (Courtesy of UIC, Special Collections and University Archives.)

Various trades that comprised the heart of Pilsen's workforce have largely disappeared. Coat makers, brewers, tractor assemblers, and brick makers are gone, but food production, restaurant services, and local tourism are on the rise. Pilsen's ability to adapt and survive has been a historical fact. (Courtesy of the Unite Here Labor Union.)

Two

PEOPLE OF PILSEN

Pilsen is like a thick ethnic soup brimming over with a variety of ingredients. It has long been a port of entry for immigrants. During the mid-19th century, the Irish and Germans were among the first European groups to arrive along with Yankees, who came from the East Coast of the United States. Soon other ethnic groups arrived. From the area of the modern Czech and Slovak Republics came the Bohemians and Moravians. (This book uses the terms Czechs and Bohemians interchangeably, but not always accurately, in reference to both groups.) Other Eastern European groups that followed the Czechs were the Slovaks, Lithuanians, Poles, and Croatians. Later Italians and Mexicans settled in as well.

There were demographic waves that caused high and low periods of immigration. World wars, political persecutions in the home countries, economic hardships, and U. S. policies toward immigration opened and closed the flow of newcomers. Today there are about 48,000 people living in Pilsen, but during the 1920s there were nearly 85,000 people according to census data. Given the high density of the neighborhood today, it is hard to imagine twice the current population inhabiting Pilsen.

Pilsen has always contained a youthful population. According to recent census reports, one-third of Pilsen is under the age of 14, and the median age of the community is 18, making it demographically one of the youngest neighborhoods in Chicago. This factor makes quality schooling of vital importance to the future of Pilsen.

The streets of Pilsen have known the footsteps of the rich and famous. The poet and troubadour Carl Sandburg, civil rights leader Cesar Chavez, and past presidents of Mexico have visited here. Notable people who were raised in Pilsen include former Illinois governor Otto Kerner, writer Stuart Dybek, former Chicago mayor Anton Cermak, and the emeritus Chicago Bears coach George Hallas. Judy Barr Topinka, who was elected to several statewide political posts, traces her family roots to Pilsen. Film stars and singers have visited Pilsen to sample the local cuisine or sign autographs.

Who knows when the next celebrity will visit Pilsen or the next young student from the local schools will become an achiever of national prominence?

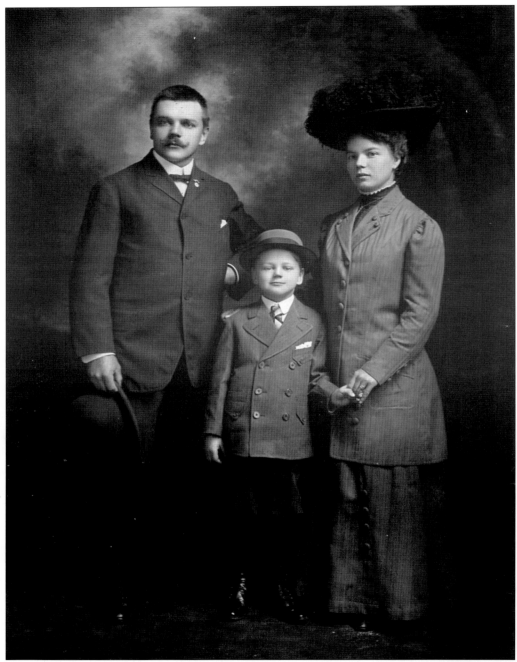

By the era of the Civil War in America, Czech people were living and working in Pilsen. Settlers from the regions of Moravia and Bohemia were part of the first wave. By the 1890s, immigrants from Slovakia also arrived in Pilsen. In this picture, members of a Czech immigrant family proudly present themselves before a portrait camera. (Courtesy of the Czech Heritage Museum.)

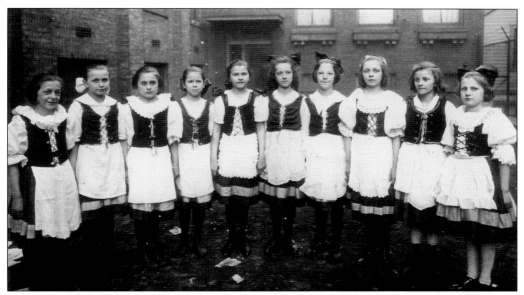

Immigrants from the Czechoslovak region worked assiduously to preserve their culture in Chicago. Dance, folklore, and sporting clubs from the old country stayed alive in Pilsen. In this photograph, Czech girls perform a dance in traditional costumes at Howell House, a settlement center on Racine Avenue, which also served Polish and Croatian immigrants. (Courtesy of Paul Nemecek.)

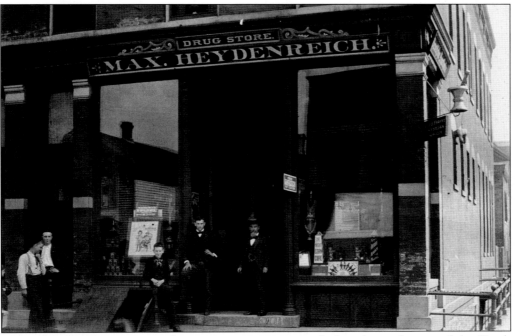

The influence of Germans in the area was apparent even before the settlement of the Czech colony in Pilsen. The Germans established prosperous businesses like the Heydenreich Drug Store, pictured here in Pilsen. The proprietors and a few customers pose for this picture at Twenty-first Street and Hoyne Avenue in 1892. (Courtesy of the Chicago Public Library, Special Collections and Preservation Division, Lo1.1.)

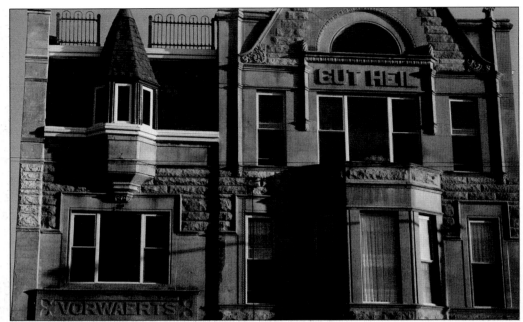

Germans established the Turnverein Society in Chicago as a cultural conduit. This building was constructed in 1896 a few blocks northwest of Pilsen. The words *gut heil* over the window offer a welcome to newcomers. The *turnhalle* was restored in 2008 by Bill Lavicka, a Chicagoan of Czech heritage. He is a structural engineer who specializes in architectural preservation. Lavicka has pioneered the restoration of Victorian houses on Chicago's Near Westside since 1975. (Photograph by P. N. Pero.)

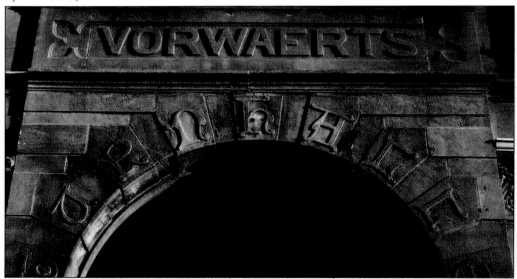

The turnhalle inscription on this archway was a welcome mat for Germans, who were former members of this athletic society in the old country. In the turnhalle, they practiced gymnastics, choral music, poetry readings, or simply relaxed among the company of countrymen. "Forward" was their motto, and it is cut into the masonry above the entry to this limestone facade. (Courtesy of William Lavicka.)

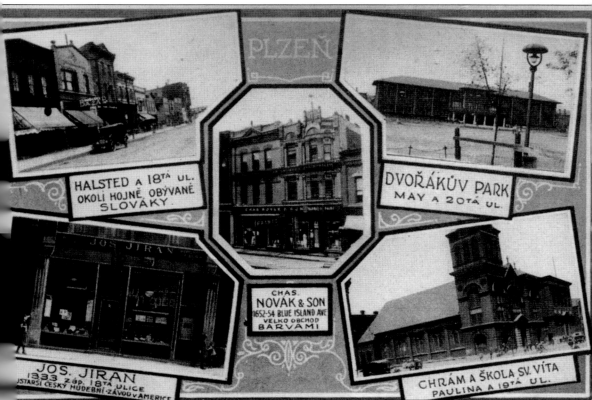

This collage by Chicago photographer Ernst F. Macha points to plenty of enterprising activity in early Pilsen that no longer exists today. The intersection of Eighteenth and Halsted Streets was the epicenter of Slovak enterprise but is today dominated by artist studios. The St. Vita Church (1888) featured a school (*skola*) that has been closed for decades. The Jiran Music Store and Novak Paint Company had prosperous but brief life spans in Pilsen. (Courtesy of the Czech Heritage Museum.)

Slovaks arrived after many Bohemians had already settled in Pilsen. The Slovaks often found blue-collar jobs in Chicago's stockyards and in factories south of Pilsen. They tended to favor a more conservative Catholicism than the freethinking Bohemians. In 1908, Slovaks founded St. Stephen's Church. The St. Stephen's chapel is today part of the Cristo Rey School on Wolcott Street. (Courtesy of the Illinois Labor History Society.)

Polish migration to Pilsen began as early as the 1870s. Many people were pushed out of their former neighborhood along Madison Street by commercial developers. By the 1960s, their presence in Pilsen rivaled the Czechs, who were already moving west beyond Lawndale in search of larger businesses and homes. (Courtesy of the Walter Reuther Library.)

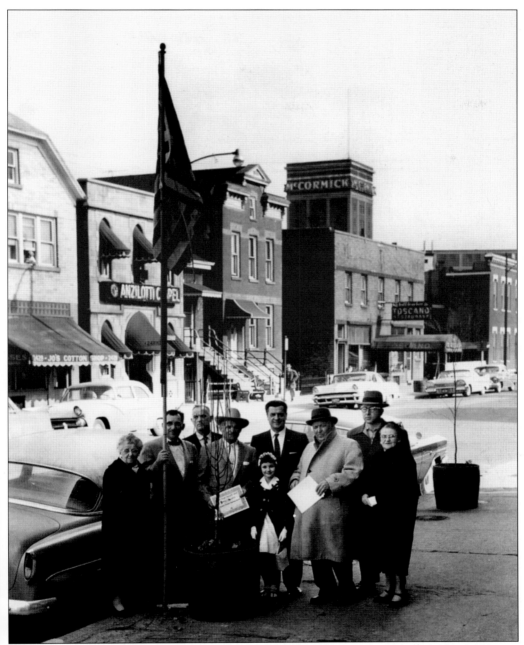

Italians resided in the southwest corner of Pilsen. A small enclave existed around the confluence of Oakley Avenue, Twenty-fourth Street, and Blue Island Avenue. Many immigrants from Tuscany settled in this pocket of Pilsen because it was an easy walk to the McCormick Reaper Factory, one of the largest manufacturing companies that survived nearly 50 years in Chicago. In this photograph, the tower of the McCormick factory looms overhead while several Italians meet on Oakley Avenue's "restaurant row" in 1958. (Courtesy of Casa Italia.)

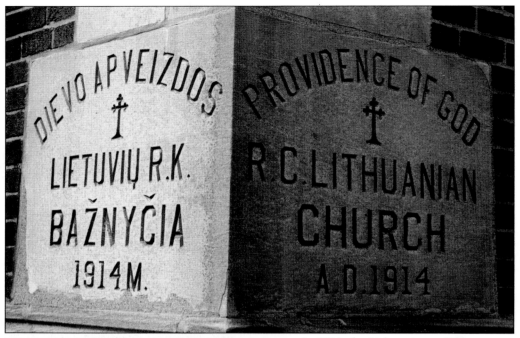

In 1914, the Lithuanians of Pilsen constructed the Providence of God Church in East Pilsen at a time when their settlement was growing. (Photograph by B. Seo.)

Today Providence of God Church sits in the shadow of the Dan Ryan Expressway at Eighteenth Place. Pope John Paul II made a personal appearance at this church when he visited Chicago in 1979. (Photograph by B. Seo.)

Evidence of the Czech presence in Pilsen can be discovered by taking a close and careful look at the neighborhood's architecture. Pedestrians passing this facade may not be aware that the building was a church constructed by the Bohemians on Paulina Street in 1888. The word *chram* cut into the masonry means "church" in the Czech language. The colorful murals on this old chapel add even more mystery for passing Pilsen pedestrians. (Mural by Ulises Villa Jr.)

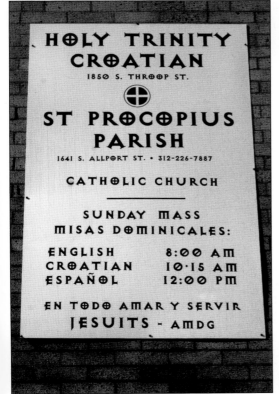

For each language spoken in Pilsen, there was a church to match it. The Croatian Orthodox Catholic Church on Throop Street is one example. When it was first created in the 1950s, services were only offered in the Croatian language. Today three languages are spoken at Trinity, and a link with St. Procopius Church has strengthened this faith community. (Photograph by P. N. Pero.)

One of Pilsen's favorite sons was Anton Cermak, who spent his boyhood years in the neighborhood. Later his family followed the westward migration of prosperous Czechs to South Lawndale. During the 1920s, Chicago was notorious for mob crime and political graft. Anton Cermak aimed to reform the city and was elected mayor in 1931. (Courtesy of the Czech Heritage Museum.)

As an influential member of the Democratic Party, Cermak escorted Pres. Franklin Roosevelt on a campaign trip to Florida. In Miami, an assassin fired a pistol at the president but killed Cermak instead. The city grieved deeply over the death of this political reformer. (Courtesy of the Czech Heritage Museum.)

Respectfully Dedicated to Chicago's Martyr.

I'M GLAD IT WAS ME AND NOT YOU

(Jsem Rád Že To Trefilo Mně)

WITH UKULELE, QUARTETTE ARRANGEMENT
AND
BOHEMIAN WORDS

Words and Music by
CHARLES KALLEN
AND
RAY ZAHER

In memoriam, a song was written inspired by a remark the mayor allegedly made from his deathbed to Franklin Roosevelt. Posthumously this immigrant from Pilsen became a legend. (Courtesy of the Czech Heritage Museum.)

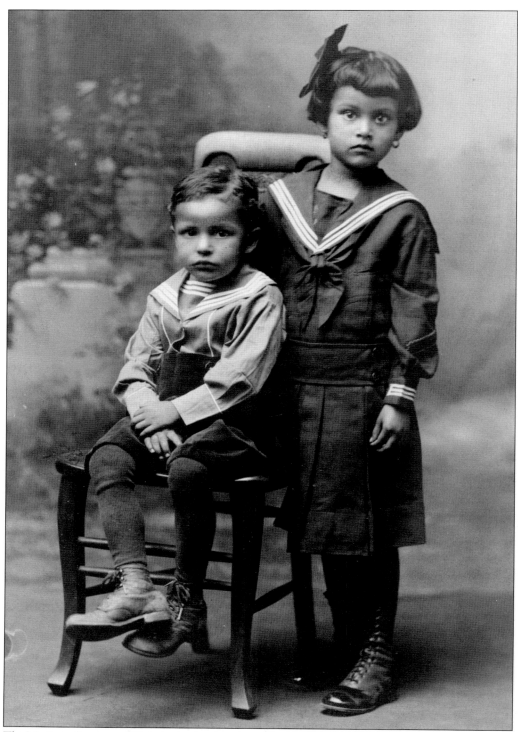

The Mexican diaspora to Pilsen is a major chapter in Chicago's history. Since the 1920s, Mexican people have lived on the city's Near Westside. (Courtesy of the NMMA, Mexican Chicago Archives.)

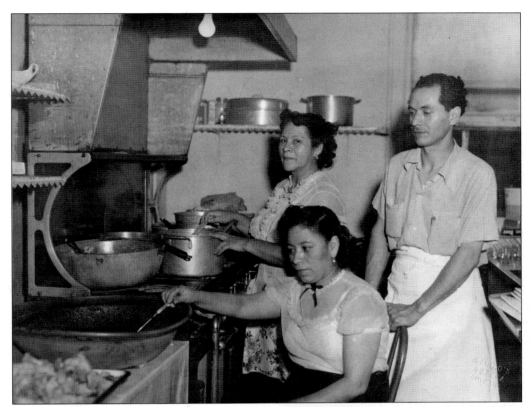

The Mexican community created a local economy that paralleled the dominant Chicago economy. Mexican family businesses offered goods and services that catered to the immigrant consumer. In this 1950 photograph, the Bautista family prepares mole sauce to be sold mainly in the Pilsen area. (Courtesy of Aurelio Barrios.)

As the Poles, Czechs, and other ethnic groups shifted to other parts of Chicago, the Mexican presence in Pilsen steadily grew. With the construction of a University of Illinois campus in 1963, hundreds of Mexican residents near Little Italy were pushed south of Sixteenth Street. (Courtesy of Aurelio Barrios.)

Today more than 80 percent of Pilsen is comprised of Latinos, but gentrification and other demographic trends may reduce this number in the next decade. The past 150 years have shown a clear pattern of ethnic succession as each group arrived and departed. (Photograph by P. N. Pero.)

Clearly the Czech population no longer has a residential presence in Pilsen, but Czech culture is well preserved in places like the Czech Heritage Museum in the western suburb of Oak Brook. Cary Mentzer helps manage the museum board and presents museum tours. Here he displays a handmade quilt. (Courtesy of Cary Mentzer.)

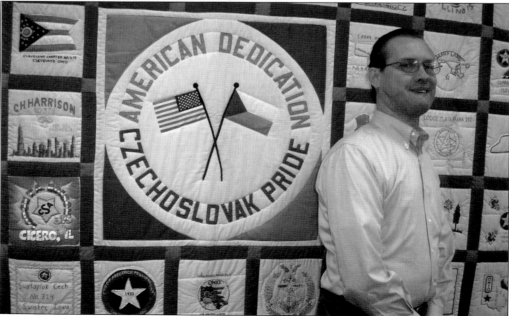

Three

PILSEN WORSHIPS

Pilsen is a community of great faith. Immigrant groups disembarking in Pilsen carried in their luggage religious traditions from their home countries. With so many languages and faiths existing in Pilsen, more than 20 churches were constructed. Architects designed these places of worship more than 100 years ago, and most are still standing today.

Immigrants in Pilsen often established a particular house of worship along ethnic and linguistic lines. Germans built St. Matthews Church, Czechs designed St. Procopius Church, Lithuanians created Providence of God Church, and Croatians established the Holy Trinity chapel. These churches built their foundations upon ethnicity. Today most churches in Pilsen are culturally mixed, but some still persist in offering bilingual worship.

Without studying census data on Pilsen, it is clear that Catholics are in the majority. One Catholic church offers six masses on Sunday along with novenas at their shrine during the week. Protestant churches exist and are growing. Few historians recognize that a Jewish temple existed in Pilsen; it was closed in 1965.

Pilsen churches are passionate about social and political issues. In times of war, the people of Pilsen draw strength from their clergy. Today a topic of debate involves the reform of U.S. immigration policy. Along with this comes the controversial issue of political asylum inside churches.

Pilsen worshipers are passionate about religious holidays and public displays of faith. In autumn, El Dia de los Muertos (the Day of the Dead) is honored in churches, and its artistic values are celebrated in schools. In spring, an annual procession in the streets of Pilsen reenacts the crucifixion of Christ. This event draws visitors to the community and plenty of photographers.

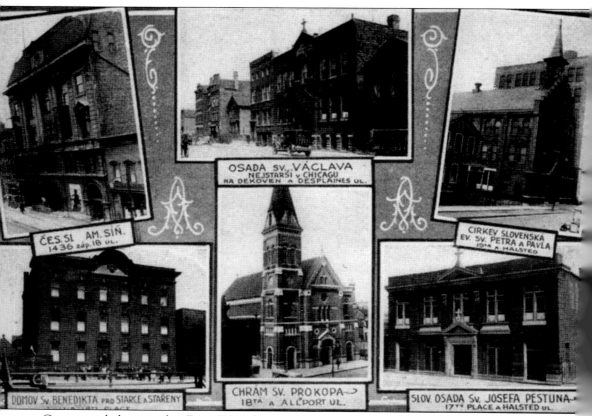

ČES. SL AM. SÍN.
1436 záp.18 UL.

OSADA SV. VÁCLAVA
NEJSTARŠÍ v CHICAGU
NA DEKOVEN a DESPLAINES UL.

CIRKEV SLOVENSKA
EV. SV. PETRA a PAVLA
19TA a HALSTED

DOMOV SV. BENEDIKTA PRO STARCE a STAŘENY

CHRÁM SV. PROKOPA →
18TA a ALLPORT UL.

SLOV. OSADA SV. JOSEFA PĚSTUNA →
17TH PLACE a HALSTED UL.

Commercial photographer Ernst F. Macha created detailed postcard views of Chicago from 1870 to 1940. Macha documented many of the Bohemian and Slovenian religious institutions on a single picture postcard shown here. (Courtesy of Czech Heritage Museum.)

This line drawing shows the first Czech church built in Chicago (right) around 1875. A much larger church was built on Eighteenth and Allport Streets by 1888. St. Procopius Church was named after the patron saint of Czechoslovakia. This was one of the most active parishes on the Near Westside of Chicago. In a typical month, more than 30 funerals and about 120 baptisms kept the Benedictine priests busy tending their flock from cradle to grave. (Courtesy of James Collins, St. Procopius Church.)

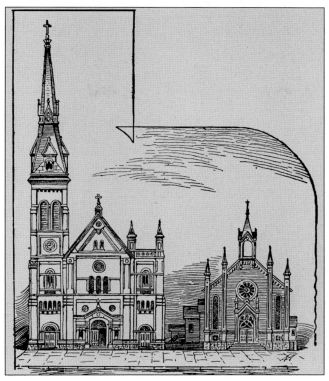

The convent was a vital part of the Procopius complex. Sisters from this convent were agents of moral instruction through the St. Procopius School, and these nuns provided changing décor for church services. (Courtesy of the Czech Heritage Museum.)

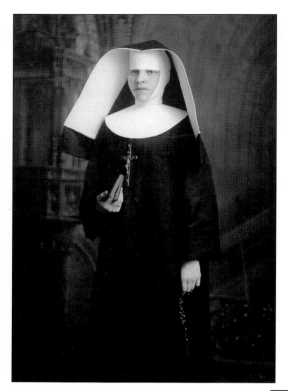

Many of these sisters from the Order of St. Francis (OSF) taught at the St. Procopius Grade School in Pilsen. The labor of the sisters was donated, and this army of dedicated nuns provided low-cost tuition for generations of children. Sr. Mary Benno, OSF, poses for this portrait in Pilsen. (Courtesy of Paul Nemecek.)

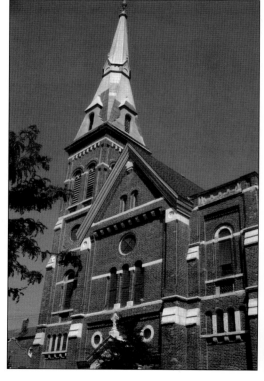

St. Procopius Church still thrives today on Eighteenth Street. It is a popular site for weddings, Mexican coming-of-age ceremonies, and a scope of services not dreamed of by the Benedictine founders in 1888. Through the Poder Outreach Center, adults can enroll in an English class or work on a high-school diploma. Children can participate in sports or religious activities organized by the Jesuits. (Courtesy of St. Adalbert's Church.)

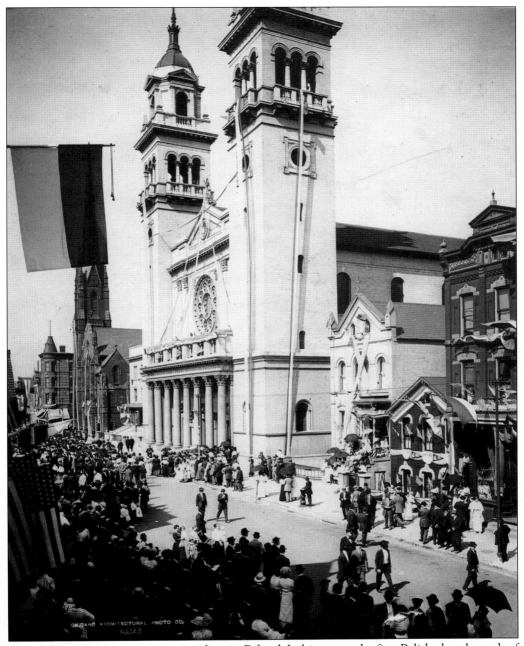

St. Adalbert was a prominent evangelizer in Poland. In his name, the first Polish church south of Chicago's Loop was established in 1874. St. Adalbert's Church by 1914 was in need of more space and constructed an elaborate Renaissance-style church in Pilsen at the cost of about $300,000. This and four other landmark churches in Chicagoland were designed by German-trained architect Henry Schlacks. (Courtesy of St. Adalbert's Church.)

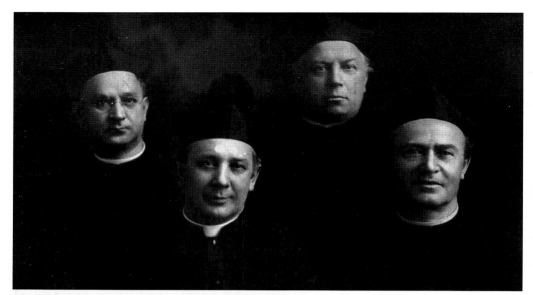

From the day the cavernous new church opened until the mid-1950s, Casimir Gronowski (second from left) led the parish. At its peak, Adalbert had a staff of 43 nuns, a school of 2,700 students, and a nursery to assist the working women of Pilsen. (Courtesy of St. Adalbert's Church.)

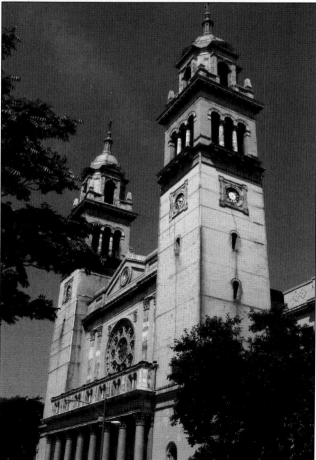

St. Adalbert's is still an active parish, mixed with Poles, Latinos, and Catholics of other nationalities. The massive church can seat nearly 2,000 parishioners, and St. Adalbert's is searching to find alternative uses for its annex on Seventeenth Street. (Courtesy of St. Adalbert's Church.)

Slovak Jews required their own house of worship. They constructed a temple in 1892, on Ashland Avenue and Twentieth Street, shown in this photograph. By the 1960s, St. Pius Church bought the synagogue building. Few residents today realize that a Jewish congregation existed in the predominantly Catholic community of Pilsen. (Courtesy of Rob Packer's *Doors of Redemption*.)

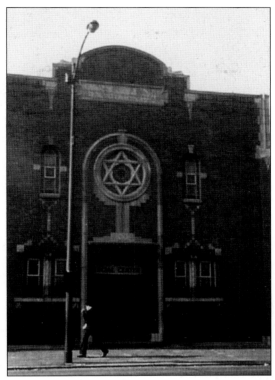

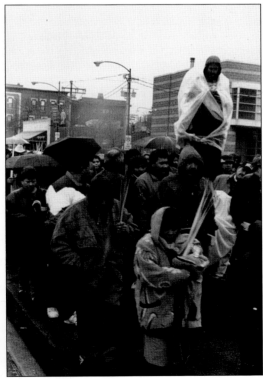

The Catholics of Pilsen actively present public displays of their faith. Religious pageants, like the Day of the Dead and the Way of the Cross, are presented annually in rain, snow, or sunshine. (Photograph by Antonio Perez.)

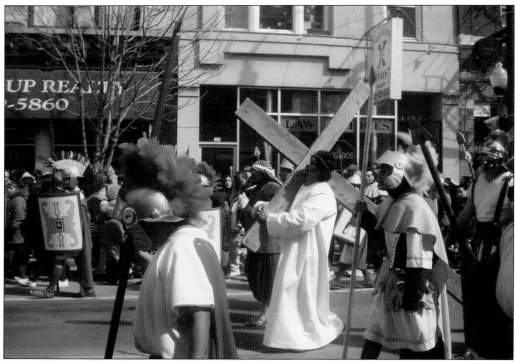

A Mexican tradition in Pilsen is the reenactment of the crucifixion of Jesus Christ. Each year, a volunteer has the honor of carrying a full-sized wooden cross through the streets. At the conclusion of the procession, the person who reenacts the role of Jesus is tied to a cross that is raised in the local park. (Photograph by Heriberto Quiroz.)

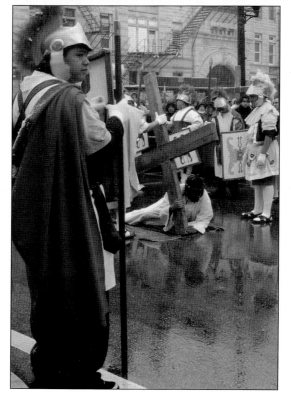

Here local residents are cast as Roman soldiers in the Passion play. All this draws plenty of photographers to Pilsen for the reenactment. In this image, there is actually snow falling on the streets and on the soldiers, which adds a bit more misery to this springtime event. (Photograph by Heriberto Quiroz.)

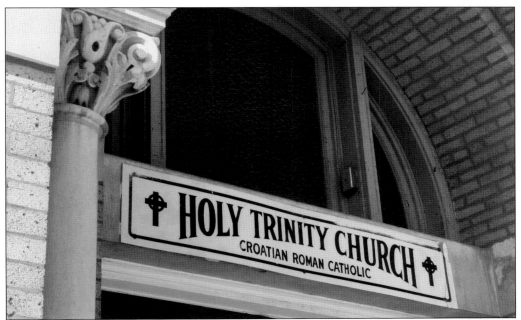

Many Croatians who settled in Pilsen wanted to attend a church with services in their language. By 1950, they established Holy Trinity Church on Throop Street. (Photograph by P. N. Pero.)

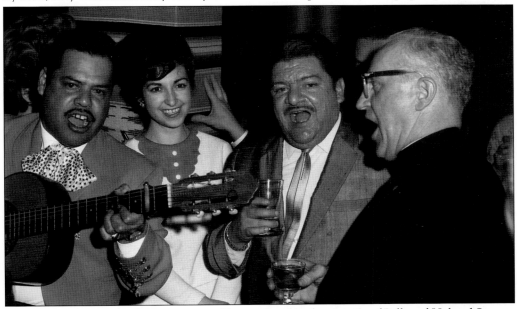

For decades, thousands of immigrants in Chicago lived in the vicinity of Polk and Halsted Streets. With the construction of the University of Illinois campus in 1963, many families, particularly Mexican Americans in this old port of entry neighborhood, were pushed to the south and into the Pilsen area. A few churches remained in the old neighborhood and lured parishioners back. Here Fr. Pat McPolin (right) leads a reunion at old St. Francis Church. This church, in the old Maxwell Street area, retained a high concentration of Mexican families who persistently preserved their church despite university incursions. (Courtesy of Aurelio Barrios.)

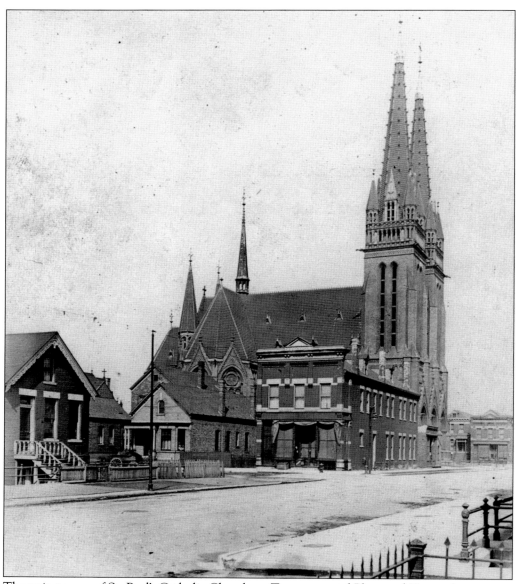

The twin towers of St. Paul's Catholic Church on Twenty-second Place and Hoyne Avenue can be seen for miles beyond Pilsen. This church resembles many cathedrals in France and Germany because the architect, Henry Schlacks, was trained in the Alsatian region of Europe. In 1876, the first families of Pilsen constructed the ground floor of the church before running out of money. They held mass in this basement for nearly 20 years until this Gothic cathedral was finally finished. Many of the brick cottages in this 1902 photograph still surround the church today. (Courtesy of the Chicago Public Library, Special Collections, lws1-2.)

Saint Vitus Parish--Chicago, Illinois

St. Vitus was a Czech church that lasted more than 75 years in the heart of Pilsen. This Catholic house of worship celebrated both golden and diamond jubilees before it was closed and converted to a social service center that still serves in the spirit and mission of the church. (Courtesy of the Czech Heritage Museum.)

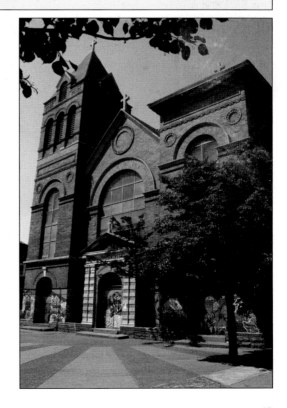

Today St. Vitus Church sits proudly on Paulina Street but serves as a center for a housing renewal project and a child care center. Raul Raymundo, a graduate of Juarez High School in Pilsen, decided to give back to his community by creating the Resurrection Project in 1990. Resurrection has created more than 300 new affordable homes with the help of 13 churches in the Pilsen Area. (Photograph by P. N. Pero.)

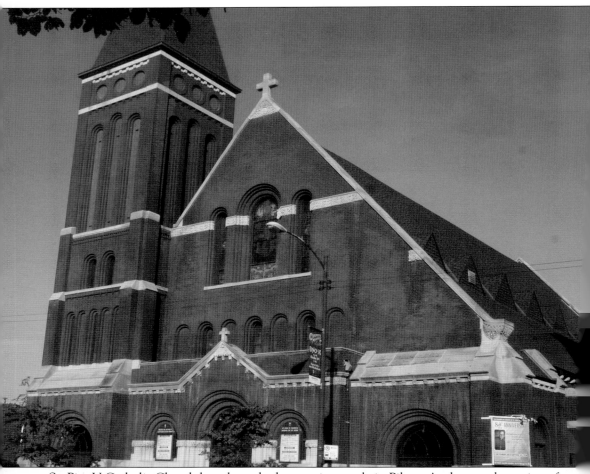

St. Pius V Catholic Church has always had a prominent role in Pilsen. At the grand opening of this church in 1893, there were 600 priests, a papal delegation from Rome, and the governor of Illinois and mayor of Chicago in attendance. Unlike the other Catholic churches in Pilsen, St. Pius was founded without preference to a particular nationality or language group. The Shrine of St. Jude, Patron of the Impossible, was created at St. Pius in 1929. (Courtesy of St. Pius V Church.)

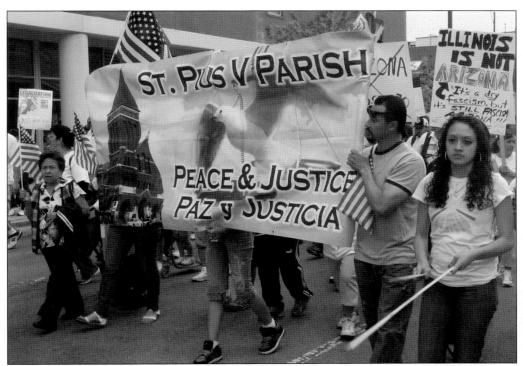

Parishioners of St. Pius are especially concerned about immigration reform in America and the separation of families due to deportations. In this photograph, church members march from the church on Nineteenth Street and Ashland Avenue to a rally in downtown Chicago. (Courtesy of Eric Schwister.)

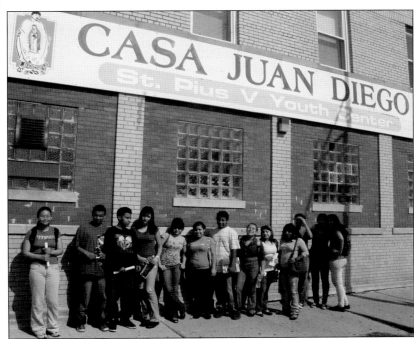

Casa Juan Diego is a satellite site of the St. Pius Church. It provides both recreation and help with homework to students of all ethnicities and faiths. Here Latino and Asian students visit "la Casa." (Courtesy of Casa Juan Diego.)

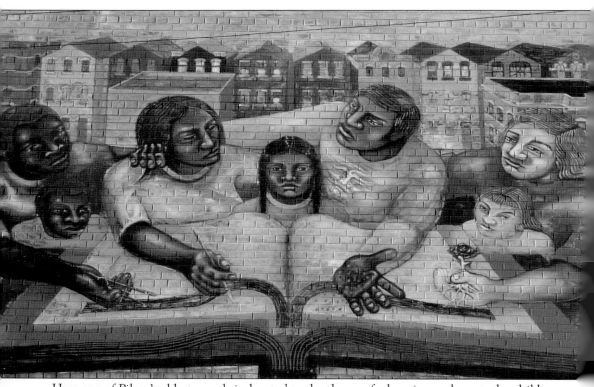

Here one of Pilsen's oldest murals is devoted to the theme of education and greets the children of St. Pius School daily as they pass through the school's main entry. (Mural by Aurelio Diaz.)

Four

EDUCATION

Education is the glue that bonds the ethnic fabric of Pilsen and prepares future generations with lifelong skills. For this reason, 11 public schools and five parochial schools operated successfully in Pilsen. Historically each school has struggled to raise capital, construct classrooms, and find staff. But most of these educational institutions have thrived and survived.

Beyond state institutional education, there were a variety of ways that immigrants educated themselves. The Germans built turnhalles, and the Czechs created something similar called *sokols*. Polish immigrants built Falcon Halls, and the Mexicans organized soccer clubs. On the surface, these organizations were about physical fitness, but there were more reasons these organizations were created: old world nationalism, mutual aid, and the preservation of language and culture from the old country were at the heart of it. Sokols and turnhalles have disappeared from Pilsen, but the goals of these organizations live on through places like the YMCA or Casa Juan Diego at St. Pius Church. In regard to more formal schooling, there are community-based groups in Pilsen like Instituto Progresso, the Yollocalli Art Workshops, El Hogar del Nino Childcare Center, or the Westside Technical Institute of Daley College. These organizations help neighbors participate in a variety of educational activities such as painting a mural, working toward receiving a high school diploma, creating a broadcast film, learning English, or pursuing a college degree.

The people of Pilsen will always seek education—be it a workshop in a church basement or a formal course at the community college.

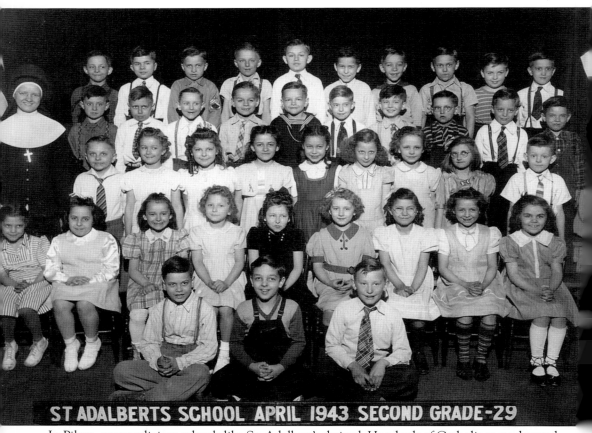

ST ADALBERTS SCHOOL APRIL 1943 SECOND GRADE-29

In Pilsen, many religious schools like St. Adalbert's thrived. Hundreds of Catholic nuns devoted years of their lives to the parish schools. Here a single teacher manages to keep 41 second-graders settled for their class photograph in 1943. (Courtesy of St. Adalbert's Church.)

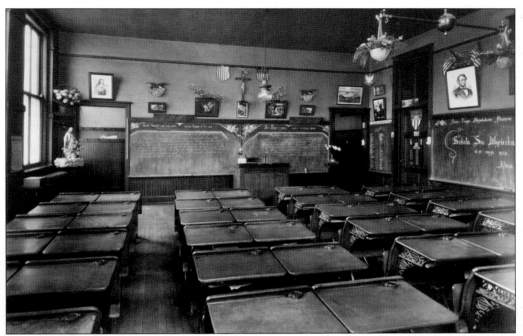

This classroom at St. Adalbert's School appears to be utilizing gas lighting. In reality, these old gas lamps were converted to flower holders once electricity was installed in the school. Icons of both Abraham Lincoln and the Virgin Mary adorn this classroom. All the chalkboard notes are written in Polish. (Courtesy of St. Adalbert's Church.)

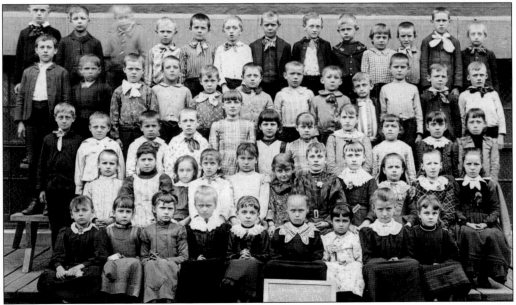

This photograph of second-grade students at Pickard Elementary School in 1891 reveals some somber and serious faces. High-top leather shoes were popular items for young students just as Nike and Converse sneakers are popular today. The Pickard students were expected to wear starched white collars for this photograph. (Courtesy Chicago Public Library, Special Collections lws1-4.)

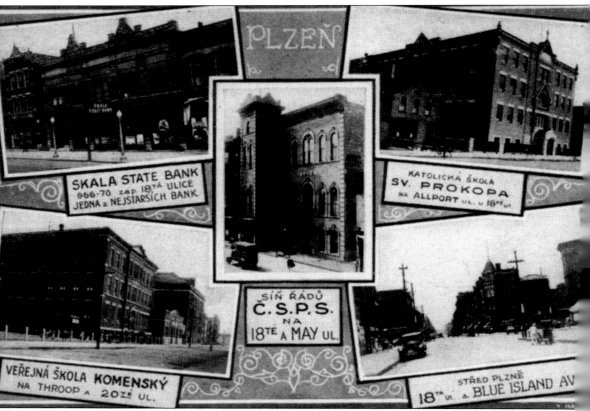

The artist E. F. Macha documented the educational and nonprofit establishments of Pilsen as well as the commercial centers. His postcard photographs preserve some of the Pilsen institutions like the St. Procopius School, the Jan Komensky Public School, and the old Czech Society Hall, which offered adult education classes in English language and citizenship. (Courtesy of the Czech Heritage Museum.)

Jan Amos Komensky was a popular Czech school reformer in 1890. The Chicago Public Schools named an elementary school after him, and by the 1960s a major wing was added. This annex was named after Manuel Perez, a war veteran from Pilsen. This sharing of heritage is typical in the neighborhood, where old ethnic traditions blend with new ones. (Photograph by B. Seo.)

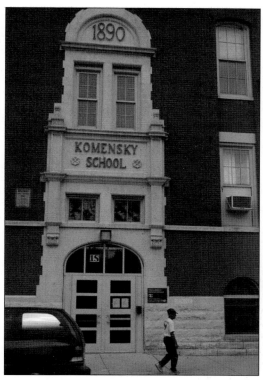

This young baseball player is a student at Cooper School and has probably refined his game in gym class. In 1885, the original construction team elaborately carved the year of completion into the wall next to the entry door. Cooper is a dual-language academy, which means that all students aim to graduate with fluency in two languages. (Photograph by P. N. Pero.)

Here a proud mother pauses on Eighteenth Street in the heart of Pilsen. She may hope the religious icon will bring good fortune to her child. In Mexico, El Dia de los Niños (Children's Day) is a popular holiday; it is celebrated in other countries, like Japan. This tradition is alive and well in Pilsen and is observed every April. (Courtesy of Margaret Neis Roth.)

The Pilsen community has one of the youngest populations in Chicago with about 30 percent of the residents under 14 years of age. Child care service is in high demand, and Pilsen parents clamor for services from home-based day care to prekindergarten. In this photograph, tiny tots follow their teachers from a child care center. (Photograph by P. N. Pero.)

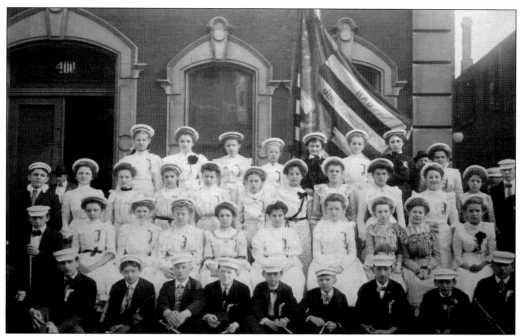

By the 1920s, more than 500 ethnic clubs and benevolent societies existed in Chicago. The purpose of these social groups was to preserve traditional customs and provide aid to countrymen. (Courtesy of the Czech Heritage Museum.)

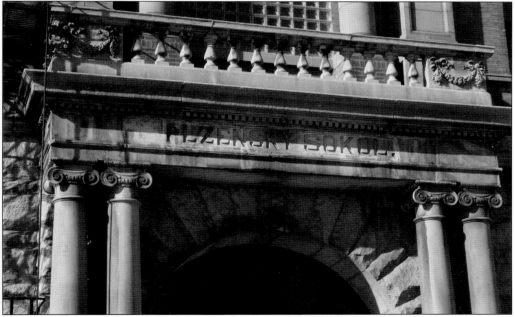

After nearly 100 years, the name Plzensky Sokol is still etched deeply into this balcony on Ashland Avenue near Eighteenth Street. This sokol was a haven for Bohemian immigrants in Pilsen, and the building offered four floors with meeting rooms, a library, and a gymnasium. (Photograph by B. Seo.)

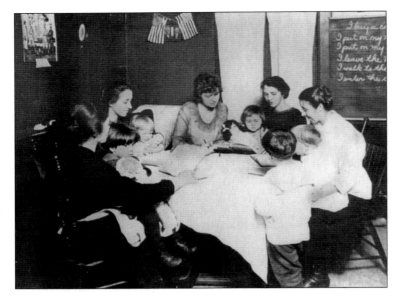

An educational goal of the sokol was to preserve the language of the old country and provide a site for learning English as well. Here a tutor offers English-language classes to immigrants. Eventually Czech-language classes moved out of the sokols and into the community public schools at places like Froebel Academy and Harrison High School. (Courtesy of the Calumet Regional Archives.)

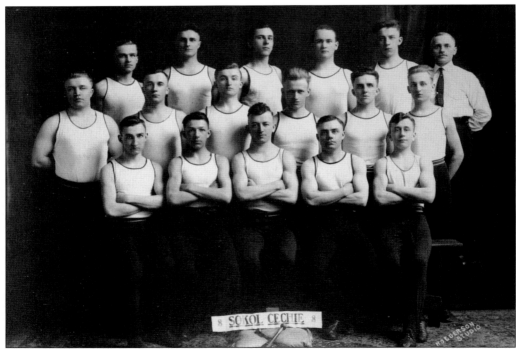

Athletics was at the heart of sokol life; gymnastics was a popular sport for the Czechs. The German Turner Hall and Polish Falcon Hall in the Pilsen area also promoted the notion of holistic physical education. A sound mind in a sound body was the philosophy behind all three ethnic organizations. (Courtesy of the Czech Heritage Museum.)

For five years, parents in Pilsen petitioned and protested at the Chicago Board of Education to build a high school in the neighborhood. At that time, most Pilsen teenagers travelled as far west as California Avenue to attend Harrison High School. By 1977, parents won consent for a new high school in Pilsen. (Courtesy of B. Seo.)

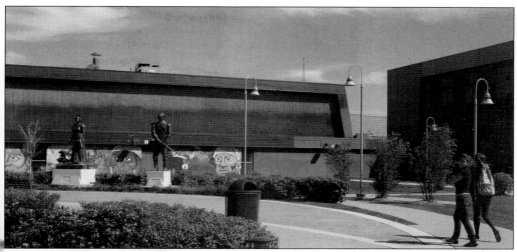

The new school was named the Benito Juarez Community Academy. It was decorated with Mexican motifs utilizing mosaics, murals, and ceramics inside and out. The style of the building reflects the lines of an Aztec pyramid at its base. The structure includes an auto shop, architectural drafting rooms, and an open floor plan for the cafeteria, central office, and library. (Photograph by P. N. Pero.)

Here is the first yearbook published by Juarez High School, featuring newly formed sports teams and clubs. Freshman students from feeder schools like Pickard, Ruiz, Jungman, and Perez were photographed, but a senior class had not yet graduated from the new school. A look at the yearbook today would feature classes in Mandarin Chinese, prenursing, television production, Aztec dancing, robotics, and many sports and clubs that students could not envision more than 30 years ago. (Courtesy of Nathaniel Foote.)

The new high school offered electronic keyboards in the music classroom and state-of-the-art science laboratories. This was before the digital revolution and computers. (Courtesy of the Juarez Yearbook Club.)

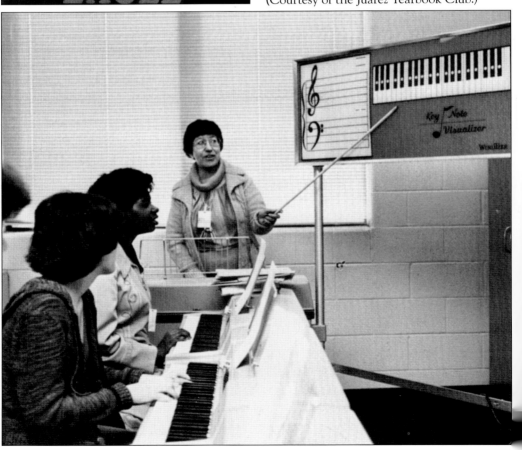

This collage shows Juarez students at work and play. One innovation for 1977 was a coin-operated wall telephone in the cafeteria for students to utilize. More than 30 years later, the school is discouraging telephones because today's cell phones disrupt the educational environment. (Courtesy of the Juarez Yearbook Club.)

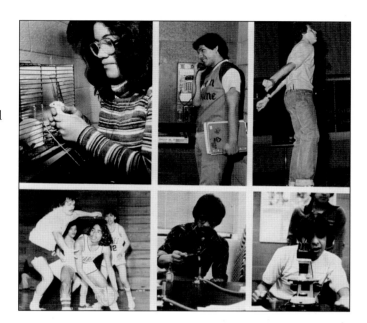

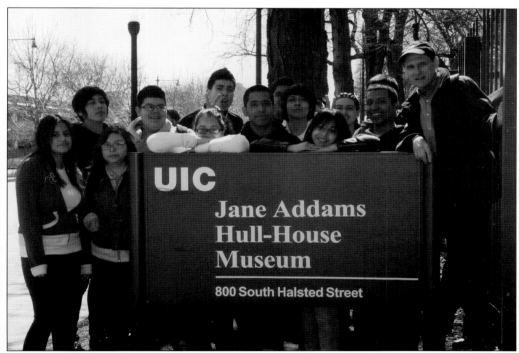

Juarez High School is fortunate to be located near the central core of Chicago. For this reason, students can take advantage of many Loop museums by using the city's public transportation. This class learned about the history of Chicago's Near Westside by visiting the Jane Addams Hull-House Museum two miles from the high school. (Photograph by B. Seo.)

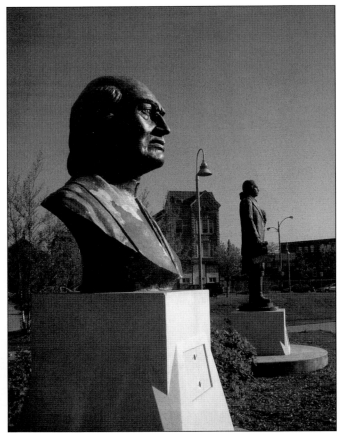

An attractive aspect of the high school is the community plaza that fronts Ashland Avenue. It contains a veritable "garden of heroes" that commemorates the history of Mexico. In the foreground of the school park is a statue of Miguel Hidalgo, who led thousands of indigenous rebels against land barons who controlled Mexico in the early 1800s; he also called for an end to the practice of slavery in the nation. (Photograph by P. N. Pero.)

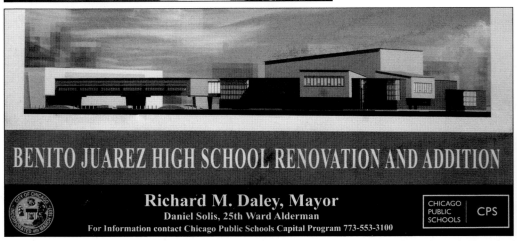

BENITO JUAREZ HIGH SCHOOL RENOVATION AND ADDITION

Richard M. Daley, Mayor
Daniel Solis, 25th Ward Alderman
For Information contact Chicago Public Schools Capital Program 773-553-3100

CHICAGO
PUBLIC | CPS
SCHOOLS

By the 1990s, Juarez required more space and upgraded facilities. In 2010, the Chicago Board of Education finally created a 60,000-square-foot annex that doubled the size of the campus. The new wing features rainwater recycling, an Astroturf sports field, and an auditorium so acoustically advanced that the Chicago Symphony Orchestra performed a premier concert to inaugurate the building and celebrate the bicentennial year of Mexican independence. (Photograph by B. Seo.)

Five

BUSINESS AND ENTERPRISE

It was beer that gave Pilsen its name. A tavern called The City of Plzen, an early Czech establishment, was the neighborhood's namesake. From the 1860s, the earliest businesses in the Pilsen community were lumberyards and canal trades that created jobs along the south branch of the Chicago River. Through enterprise and large-scale capital investment, Pilsen grew into a manufacturer of bricks, beer, farm implements, leather, and other value-added goods by the end of the 1800s.

Full employment meant home construction and the ancillary retail stores necessary to support a burgeoning community. Butchers, clothiers, mechanic shops, and a plethora of mom-and-pop stores lined the commercial corridors along Blue Island Avenue, Ashland Avenue, and Cermak Road. Even today, Cermak Road from Pilsen to the western suburbs is second to Michigan Avenue for Chicago merchandise sales. Through each decade of Pilsen's growth came more mature businesses. Lurie's Department Store on Blue Island Avenue and Eighteenth Street was the "Marshall Field's of Pilsen"; by walking to Lurie's, smart shoppers could save on paying streetcar fare to the Loop.

The old Leader Store on Paulina and Eighteenth Streets was an ideal outlet for purchasing Catholic school uniforms or handmade feather comforters that were popular with European immigrants. Larger downtown department stores did not always cater to the needs of the immigrant clientele. The Leader Store continued to serve loyal customers until the 1970s.

Today commerce in Pilsen has changed dramatically. Food manufacturing has replaced "rust-bucket" industries. Pilsen excels in the production of specially prepared ethnic foods. The V & V Supremo Company produces fine cheeses, and the Hofmeister Company specializes in prepared hams and meats. Azteca Foods Incorporated was started by Arturo Velasquez, who came to Pilsen more than 50 years ago as an immigrant. Today his company has become one of the largest food manufacturing companies in Chicago.

Apart from food manufacturing is the risky business of the restaurateur. Some started as pushcart vendors, but today more chefs are heavily capitalized and serving sophisticated cuisine in Pilsen. A selection of these food emporiums is included among the photographs that follow.

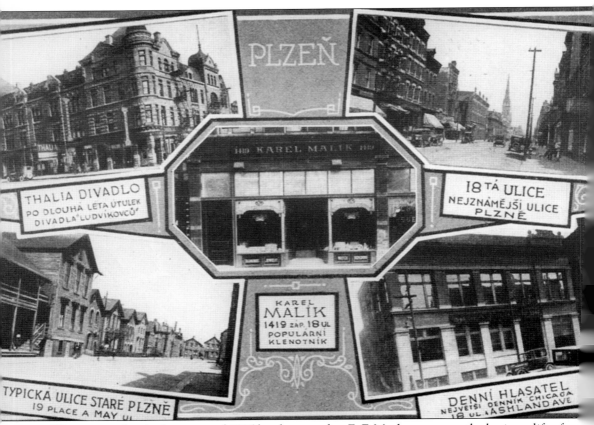

PLZEŇ

THALIA DIVADLO
PO DLOUHÁ LETA ÚTULEK
DIVADLA "LUDVÍKOVCŮ"

KAREL MALÍK

18 TÁ ULICE
NEJZNÁMĚJŠÍ ULICE
PLZNĚ

KAREL
MALÍK
1419 ZÁP. 18 UL.
POPULÁRNÍ
KLENOTNÍK

TYPICKÁ ULICE STARÉ PLZNĚ
19 PLACE A MAY UL.

DENNÍ HLASATEL
NEJVĚTŠÍ DENNÍK CHICAGA
18 UL. ASHLAND AVE.

This postcard series from around 1925 by photographer E. F. Macha preserves the business life of the Czech community from Pilsen and to the west into "Czech California," or Little Village as it is called today. This Macha card promotes some popular enterprises in the neighborhood. At the top left of the postcard is a rare photograph of Thalia Hall. A more detailed photographic documentation on its recent restoration follows later in this chapter. (Courtesy of the Czech Heritage Museum.)

The Pilsen community took its name from a popular Czech tavern, The City of Plzen. Taverns in Pilsen were social havens for men and affectionately known as "the third place," an alternative to the workplace and home. The wood-framed tavern in this photograph is of a similar vintage to the City of Plzen tavern. (Courtesy of the Czech Heritage Museum.)

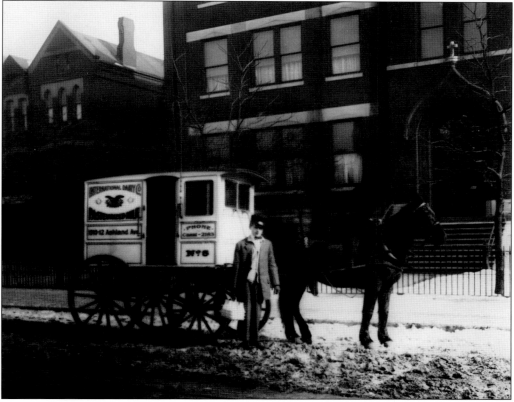

This milk wagon pauses in front of the St. Pius rectory on Ashland Avenue near Twentieth Street. Dairy and baked goods were made fresh daily and delivered to homes throughout Pilsen. (Courtesy of the Czech Heritage Museum.)

Before big supermarkets in Chicago, meat was a specialty item that could be purchased in local neighborhood stores. Lamb, poultry, and beef were often prepared to suit the pallets of immigrant customers. These Czech butchers gathered in 1936 to form an association for the improvement of working conditions. (Courtesy of the Czech Heritage Museum.)

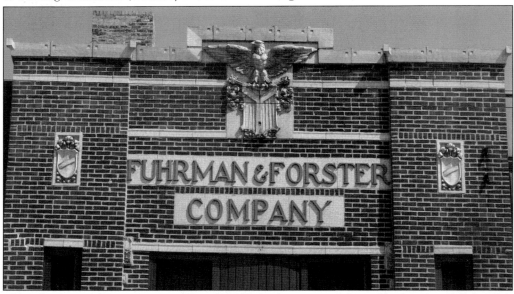

The Fuhrman and Foster Company produced ham, bacon, sausage, and lard at this plant at Blue Island Avenue and Eighteenth Street in the heart of Pilsen. The company ran a fleet of 75 delivery trucks per day to Chicago and suburban retailers. The meat company is now out of business, but this Prairie-style structure still exists in the heart of Pilsen. Ironically, the state unemployment office now occupies the building, and the closest scent of ground beef comes from a McDonald's drive-thru across the street. (Courtesy of B. Seo.)

Blanco's Family Market stood near the corner of Eighteenth Street and Ashland Avenue in Pilsen. This mom-and-pop store sold candy, canned goods, meats, fresh produce, and toys for children. The photograph, taken in 1962, shows a shop that no longer exists after the Payless Shoe Company took over the property. (Courtesy of Adalberto Barrios.)

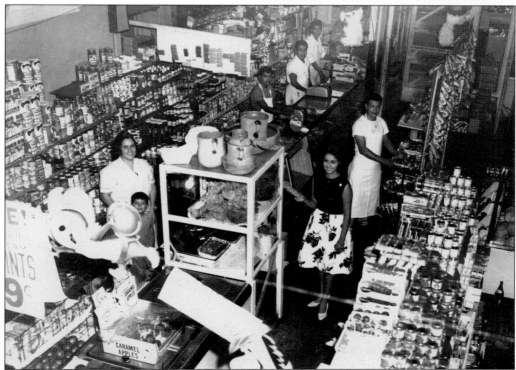

El Esfuerzo Store was the kind of shop with something for everyone. Aisles were stocked high with canned goods and produce. Such retailers have today been eclipsed by big-box hypermarkets and chain stores. (Courtesy of the NMMA, Mexican Chicago Archives.)

ČESKO-SLOVANSKÁ BANKA
F. J. Skala & Co.

966-970 W. 18TH ST. CHICAGO, ILLINOIS

Czech immigrants formed a thrifty community in the Pilsen area. Many squirreled away their wages in order to pay full price for a bungalow or two-flat building. The Skala Bohemian-Slovak Bank was a popular place for immigrants to deposit their paychecks. Some downtown Chicago banks would not make loans to blue-collar workers, so revolving loan plans were created by Pilsen savings and loan companies or by fraternal credit unions. (Courtesy of the Czech Heritage Museum.)

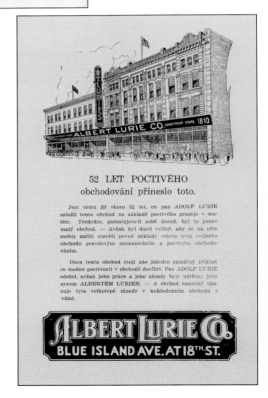

The Albert Lurie store at Eighteenth Street and Blue Island Avenue was Pilsen's major department store during the 1920s. With four floors of merchandise, it was a predecessor to larger community stores like Goldblatt's and Wieboldt's. (Courtesy of the Czech Heritage Museum.)

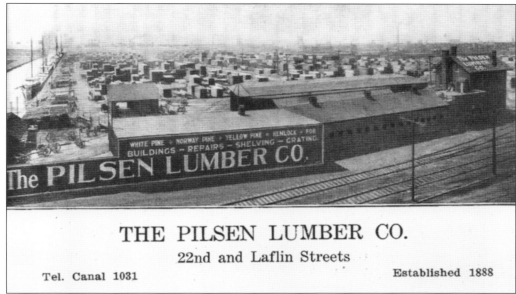

THE PILSEN LUMBER CO.
22nd and Laflin Streets

Tel. Canal 1031 Established 1888

The Pilsen Lumber Company was typical of the early industries that flourished in the neighborhood (as outlined in chapter one). Here the lumberyard is not just shoving freshly cut trees onto barges but selling fine lumber to retail customers who will begin construction as soon as the delivery truck reaches them. This lumberyard was replaced by a Coca-Cola distribution warehouse 100 years later. (Courtesy of the Czech Heritage Museum.)

During the 1950s and 1960s, many Polish merchants increased their presence on Eighteenth Street and bought out some Czech businesses. This print shop actually delivered copies to customers unlike the self-serve print shops that exist in Chicago today. (Courtesy of the Czech Heritage Museum.)

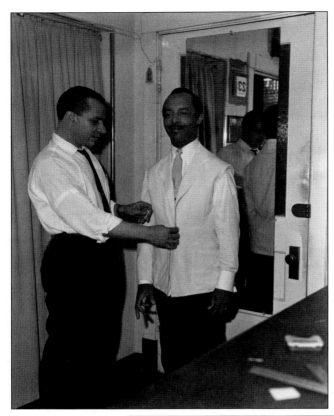

From his small shop in Pilsen, Florentino Mendez did fine tailoring for artists and celebrities. Here he adjusts a button for Perez Prado, "the Mambo King," before a musical performance in the Loop. (Courtesy of Aurelio Barrios.)

High fashion could be purchased on Eighteenth Street as evidenced by this ad for flapper-style clothing. The merchant was obviously Czech but promoted an American fashion craze. (Courtesy of the Czech Heritage Museum.)

NEJVĚTŠÍ VÝBĚR

dámských a dívčích kabátů a šatů naleznete u

JAMES PLHÁK

1515 W. 18. Street.

blíže Ashland Avenue.

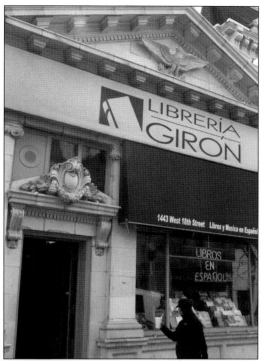

Julio and Ada Giron started a television repair shop at 1443 West Eighteenth Street and decorated some television consoles with books. The family quickly learned that customers were more interested in the books than the televisions. By 1975, the store shifted to selling Spanish-language books and musical recordings, not only from Mexico but also from Spain and many countries in South America. The bookstore is the site of an old Czech savings bank of neoclassical design. In the photograph below are, from left to right, Libreria Giron president Juan Manuel Giron, chef Juan Alfredo Oropeza of Televisa Media, and Juan Giron's wife and son, Sandra and David. The photograph is based on a promotion for a new gourmet cookbook. (Courtesy of the Giron family.)

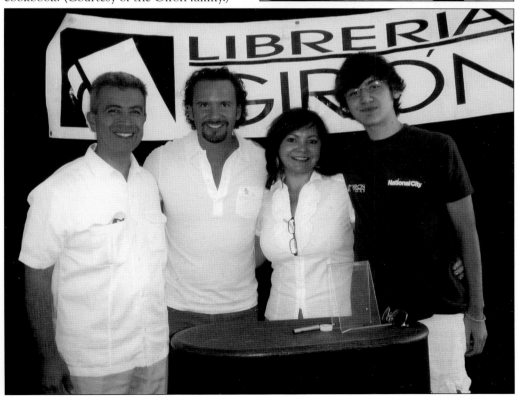

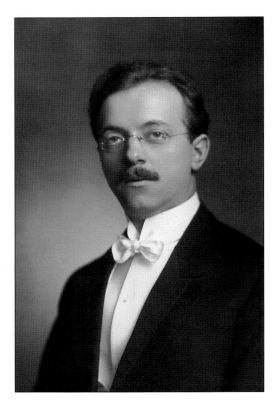

Francis D. Nemecek was a successful artist and entrepreneur in Pilsen. His story is vital to the gestation of this Arcadia book. Nemecek was born in Bohemia but attended grade school at St. Procopius School in Pilsen. His vocational training was in photography. Nemecek was commercially active across the city, but his home base was in Pilsen from 1903 to 1950. (Courtesy of Paul Nemecek.)

Francis Nemecek's home and studio stood at the corner of Bishop and Eighteenth Streets. It was designed and constructed in 1907 by a Prague architect in the neoclassical style. A special feature was the top-floor skylight that permitted plenty of sunlight to flood the studio. This feature was essential for shooting private portraits before the invention of flashbulbs and strobe lights. (Courtesy of the Czech Heritage Museum.)

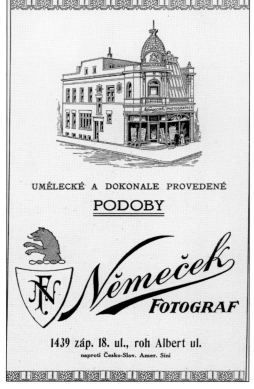

Following its use as a photograph studio, the Nemecek gallery became a barbershop for 30 years. When haircutting ended in 1984, this historic corner evolved into the Café Jumping Bean, a popular spot for artists to meet and for occasional art shows in Pilsen. Through the creation of the café, this architectural jewel box returned to its artistic origins. (Courtesy of Café Jumping Bean.)

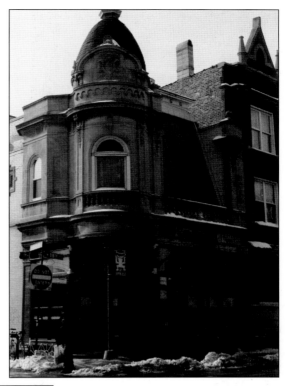

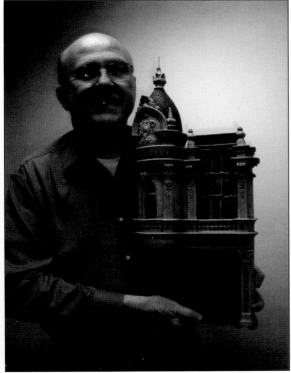

To commemorate the 100th anniversary of this old baroque-style structure, a clay model was given to Paul Nemecek, the grandson of Francis D. Nemecek, who originally built the photograph studio in Pilsen. Paul is now the director of the Czech and Slovak American Genealogy Society of Illinois and keeps the flame of Czech history alive. (Courtesy of Paul Nemecek.)

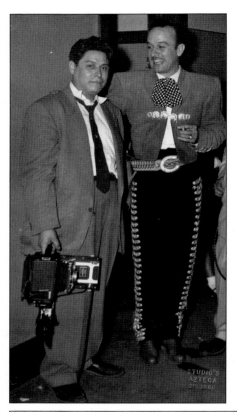

A Mexican photographer who shot nearly 5,000 pictures of Pilsen was Adalberto Barrios (left) who chats with movie star Pedro Infante in this photograph. This is one of the few times the photographer consented to stand on the subject side of the camera. (Courtesy of Aurelio Barrios.)

In 1960, Adalberto created a shop called Studios Azteca in Pilsen, where he based his citywide photograph business. In this 1969 shot, Barrios captured a friend standing at the shop entry. (Courtesy of Aurelio Barrios.)

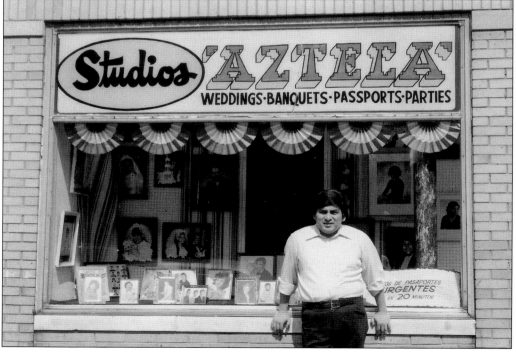

Amalia Mendoza was a singer, actress, and international movie star. She visited Pilsen in the 1950s, signed autographs, visited a local printing shop, and posed for photographs. In this shot, Mendoza (left) poses with Petra Gloria Barrios, the wife of the Studio Azteca photographer. (Courtesy of Aurelio Barrios.)

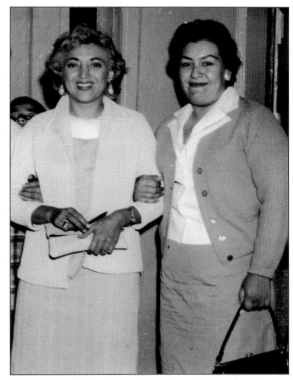

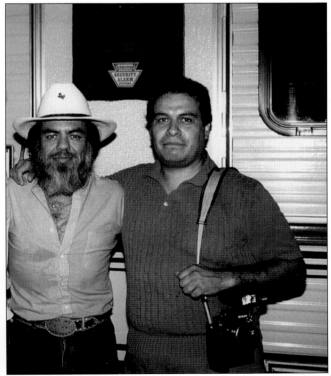

Aurelio Barrios (right) is the son of Pilsen photographer Adalberto Barrios. Today Aurelio continues his father's tradition of documenting Pilsen history with a camera. Here he accompanies Little Joe Hernandez, a popular bandleader, at Pilsen's Fiesta Del Sol Festival. Little Joe and his band are ambassadors of Tex-Mex style music in the United States, and they have exported their musical product to Asia as well. (Courtesy of Aurelio Barrios.)

The annual open house and gallery walk in East Pilsen gives Chicagoans a chance to view artists' homes, studios, and cutting-edge artwork. (Photograph by P. N. Pero.)

This innovative restoration of the old Zion Lutheran Church (1880) is the craft work of members of the Podmajersky family who, for more than 45 years, have restored industrial and residential properties in East Pilsen. With this German-styled Gothic church, the preservationists chose to restore only the bell tower and a few "bones and sinews" above the choir loft. The remainder of the church was truncated and hollowed out to form a sunken "sanctuary garden" behind the wrought-iron fence on Peoria Street. The church has taken on a new life as a place of meditation, art exhibits, and an occasional outdoor wedding. John Podmajersky Sr. and his son have attracted so many designers, architects, and artists to East Pilsen that the area is now affectionately referred to as "Soho" on Halsted Street. (Photograph by B. Seo.)

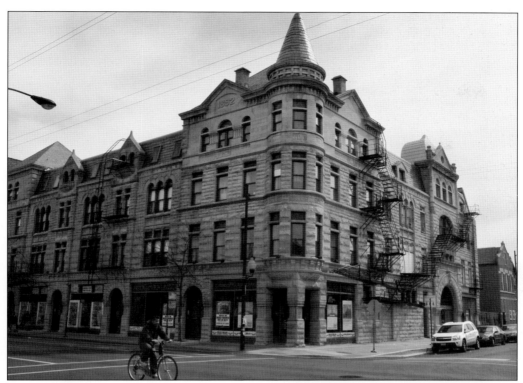

The evolution of the old Thalia Bohemian Hall is a Cinderella story. From the 1960s, the hall fell into commercial decline, and homeless campers, vandals, and stray animals began to fill some of the vacant rooms in this Romanesque-style castle. Today the brownstone facade and gilded interior gleams as the result of a million-dollar renovation by the Geraci family of Chicago. (Courtesy of Ristorante Al Teatro.)

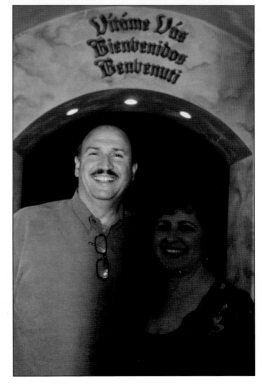

In 1994, Dominic Geraci and his wife, Caterina, found Thalia Hall in a shambles. They realized the building had historic and artistic merit. (Chapter six has a history of Thalia.) With David Bozic and several talented artists, the building was restored to its original Victorian splendor with touches of art nouveau. Dominic and Caterina are standing below three welcome signs they painted in Bohemian, Spanish, and Italian to reflect Pilsen's immigrant past. (Photograph by P. N. Pero.)

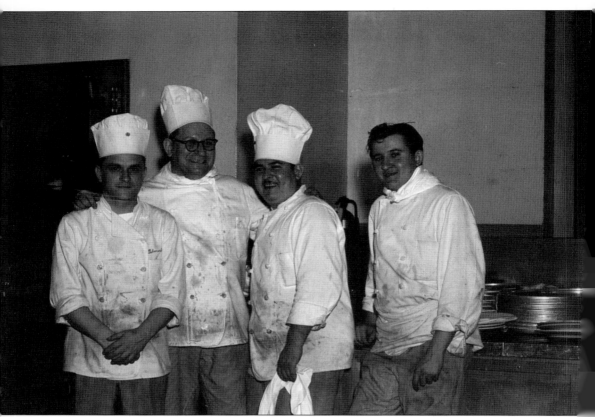

In the culinary arts, many chefs and kitchen workers showed off their talents in Pilsen. Bohemian duck, Mexican mole sauce, Polish sausage, and Italian eggplant were items that drew visitors to a variety of Pilsen restaurants. The unidentified young man on the far right wears no hat because he is an apprentice chef. (Courtesy of Aurelio Barrios.)

Nuevo Leon is the flagship restaurant of Pilsen. For thousands of visitors, it is their first stop in discovering the neighborhood. They later move on to more discreet or sometimes exotic Pilsen eateries. In 1962, Nuevo Leon was started by the Gutierrez family as a small taco stand but grew into a full-size family restaurant with valet parking. It seats hundreds of diners who are entertained by mariachi minstrel music while they eat. (Photograph by P. N. Pero.)

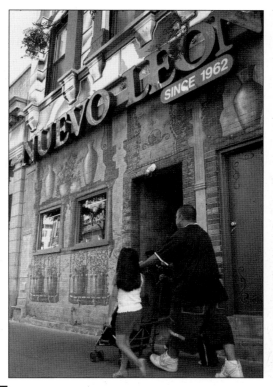

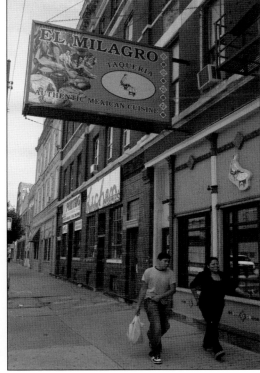

A walk through Pilsen brings the comforting smells of corn and flour dough being prepared in kitchen/factories like El Milagro. This company has capitalized on its factory site by adding a restaurant that serves tortillas that were manufactured less than an hour before diners sit down to the table. (Photograph by B. Seo.)

Many businesses in Pilsen started from humble pushcart operations. This ice-cream vendor rings his chimes to call customers on a hot summer day. Nearly anything that can be eaten off a stick or carried by hand can be sold by resourceful street vendors in Pilsen. (Photograph by P. N. Pero.)

Six

CELEBRATING THE ARTS

Dancers, muralists, musicians, novelists, poets, opera singers, and other artists have presented their crafts on the streets and stages of Pilsen. The mural may be Pilsen's best-known art form. Beginning in the 1960s, muralists captured the attention of the art world by painting their colorful messages on homes, schools, churches, and businesses.

If architecture can be called the mother of all art forms, then Pilsen's architecture is truly a mother to the Chicago art scene. The Francis D. Nemecek home and studio on Eighteenth and Laflin Streets is a noteworthy landmark. It was designed by a Czech architect in 1909. This photography studio was built in the Baroque style more typical of Prague than of Chicago. As a fine arts café, the building today offers a forum and a quick meal for many artists in Pilsen.

Another masterpiece is Thalia Hall. It is a massive Romanesque-style multipurpose building that occupies nearly the whole block at Allport and Eighteenth Streets. Thalia Hall's design was based on a 19th-century opera house in Europe. Today the new owners of the hall are trying to restore the building's Victorian furnishings, gilded dining room, and opera stage.

In addition to grand structures in Pilsen, there are more humble working-class cottages and two-flat buildings that have survived a century of Chicago weather. Adventurous real estate developers have invested in almost any type of Pilsen architecture with the hope of reselling the property for a profit. The question remains whether local preservationists or outside speculators will shape the future of Pilsen.

In the area of music, a "grateful noise" often flowed out of churches on Sunday mornings and from taverns on Saturday nights in old Pilsen. During the 1960s and 1970s, huge meeting halls opened their doors to young music lovers in the neighborhood. Typical hot spots were Union Hall, St. Procopius Hall, Smirna Hall, and Falcon's Hall. Today mariachi musicians stroll through Pilsen streets and restaurants during weekends, but there is also room for soul, jazz, and bluegrass music too.

In literature, the streets of Pilsen have inspired writers like Carl Sandburg, Stuart Dybek, and Carlos Cortez. In the future, more creative careers will flourish in Pilsen as the neighborhood shifts from blue-collar industries to entertainment and the arts.

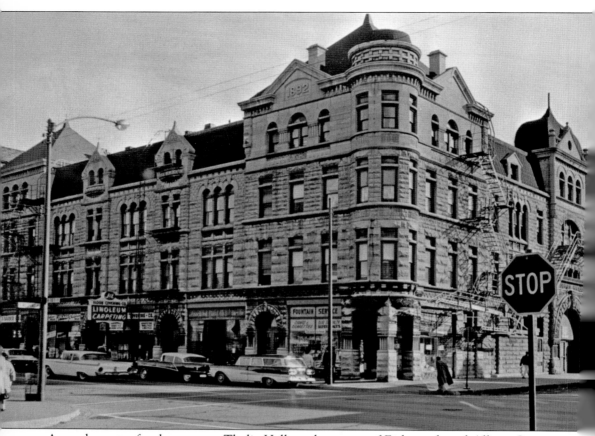

An early center for the arts was Thalia Hall on the corner of Eighteenth and Allport Streets. Completed by 1892 for the Columbian Exposition, Thalia offered an opera house, meeting rooms, shops, and apartments. Thalia was also a hotbed of political activity. A draft of the Czech national constitution was written in the upper meeting hall during the World War I era. (Courtesy of the Chicago History Museum, i13739.)

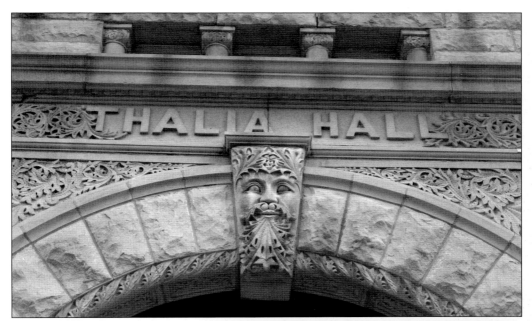

Thalia is the Greek muse of comedy and poetry. The face of Thalia graces the entrance to this Romanesque-style auditorium, and thousands of Czech immigrants saved their pennies for a ticket to the opera in the late 1800s. (Courtesy of Dominic Geraci.)

Frantisek Ludvik brought his actors from Prague to Pilsen in 1893, and his thespians became the resident company at Thalia Hall for years. The Ludvik Players introduced works by Shakespeare and Puccini to eager audiences. This was a time before radio and the movies brought entertainment to the masses. (Courtesy of the Czech Heritage Museum.)

By the 1920s, vaudeville became more popular on the Thalia Hall stage than Bohemian Opera productions. Here one performer with a top hat and false moustache presents a comedic skit. (Courtesy of Paul Nemecek.)

As vaudeville lost its popularity, the Thalia auditorium tried screening movies as a means to attract new customers. By the 1960s, even film could not make the 1,000-seat auditorium profitable, and the theater closed. (Courtesy of the Czech Heritage Museum.)

MURRAY & MAHNKE
Owners

THOS. A. MURRAY
Manager

THALIA THEATRE

1215 to 1225 West Eighteenth Street

VAUDEVILLE AND MOTION PICTURES

RODINNÉ DIVADLO

The Milo Movie Theater was a popular site for film in Pilsen. At 1821 West Blue Island Avenue, Milo was often called "Teatro Villa" by Latino moviegoers. The movie house, shown here in 1956, was eventually demolished to make way for a parking lot—a tragic end to a Pilsen treasure. (Courtesy of Aurelio Barrios.)

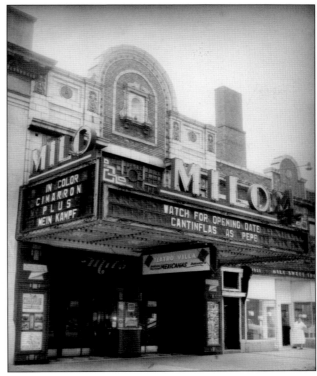

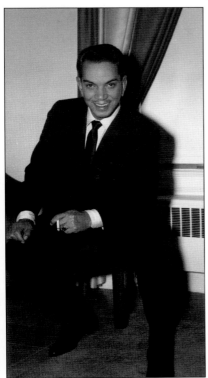

One Mexican superstar who drew crowds at area movie houses was Mario Moreno, also known as "Cantinflas." Here he visits a Chicago hotel to kick off a movie premiere. His movies at the Milo Theater in Pilsen were often packed with fans during the 1950s. (Courtesy of Aurelio Barrios.)

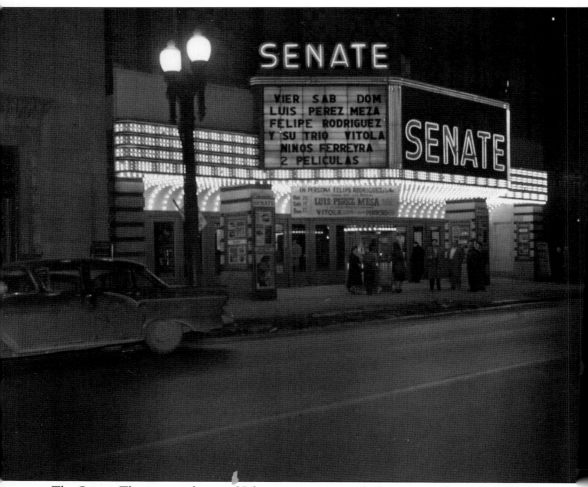

The Senate Theater, northwest of Pilsen, was a magnet for big-name Latino entertainers and their fans. Pilsen residents were treated to elaborate musical productions at the Senate. Live performances by Pedro Infante, Maria Victoria, and big Latino bands were common. A victim of the changing music scene, the Senate Theater finally closed its doors in 1969. (Courtesy of Aurelio Barrios.)

Pop music groups in the 1950s had a large following in Pilsen. The Casanovas, a Chicago soul music group, drew teen crowds to Union Hall at Racine Avenue and Eighteenth Street. (Courtesy of Aurelio Barrios.)

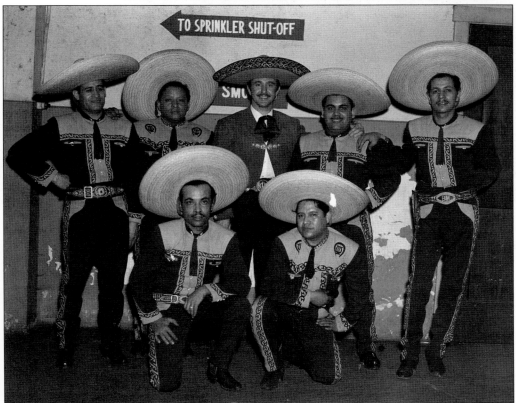

Musicians from Mexico brought traditional Latino sounds to Pilsen. This band called Los Mariachis de Potosi poses for a photograph at a dress rehearsal. Mariachi music relies on traditional musical forms form the heart of Mexico. It mixes strings, brass, and voices sonorously. Today strolling mariachi musicians still visit restaurants and perform on the streets of Pilsen. (Courtesy of Aurelio Barrios.)

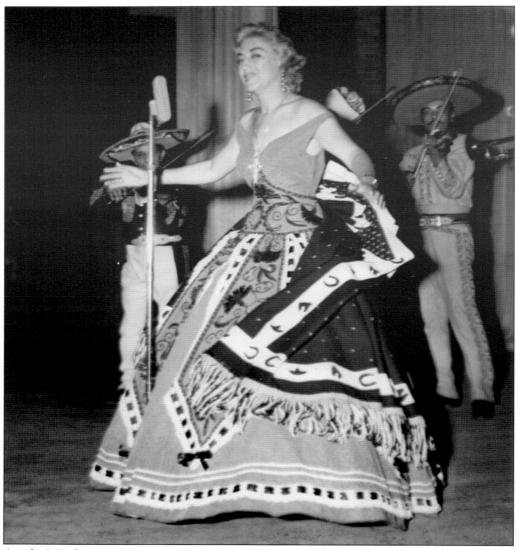

Amalia Mendoza was a major Mexican stage and recording artist. During a publicity tour in the 1950s, Mendoza visited local shops in Pilsen. She tried to operate a printing machine at the old International Press Company on Eighteenth Street. Her local fans enjoyed this publicity event. (Courtesy of Aurelio Barrios.)

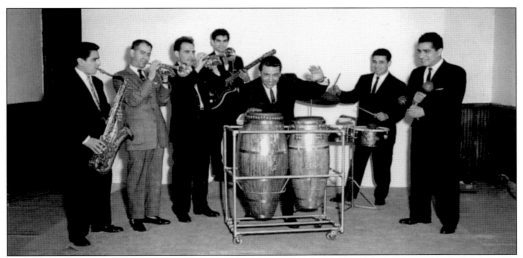

Tony Gomez and his professional players brought the Latin big band sound to Pilsen. Here they pose at Studio Azteca on Eighteenth Street in Pilsen for a promotional picture by neighborhood impresario Adalberto Barrios. (Courtesy of Aurelio Barrios.)

Pulaski Hall at Ashland Avenue and Seventeenth Street was a former brewery and a venue for traditional Polish dancing. In the 1960s, this social hall was destroyed by a fire, but the bust of Kasimir Pulaski was relocated to the Polish Highlanders Hall on Archer Avenue, where it sits today. (Courtesy of Daniel Pogorzelski.)

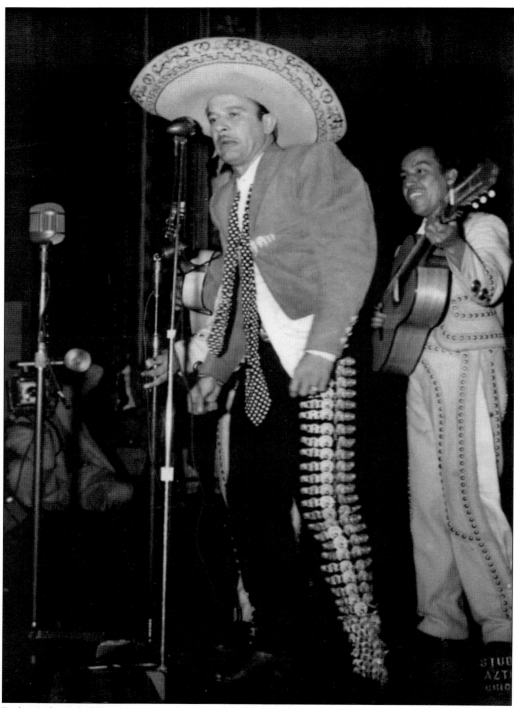

Pedro Infante held superstar status on stage and in the movies. Here in full regalia, the romantic caballero shares a song with his Chicago fans in 1960. (Courtesy of Aurelio Barrios.)

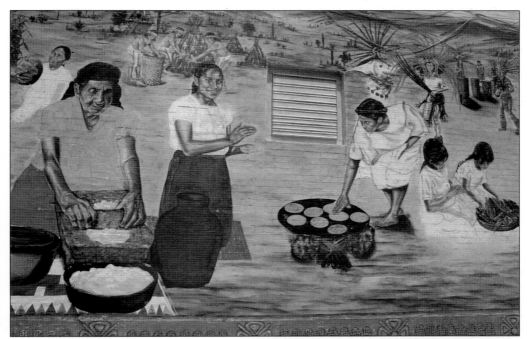

By the 1960s, the neighborhood murals began to attract the attention of the art world beyond Pilsen. This one on the south facade of El Milagro Tortilleria explains the long process of making tortillas, from the cornfield to the cooking grill. (Photograph by B. Seo.)

The vaquero (or cowboy) is a popular image in Mexican song, film, and paintings. Here is a towering mural of John Sebastian, a popular music star from the state of Michoacán. He also worked as a meat cutter in Pilsen before becoming a world-class recording artist. (Photograph by P. N. Pero.)

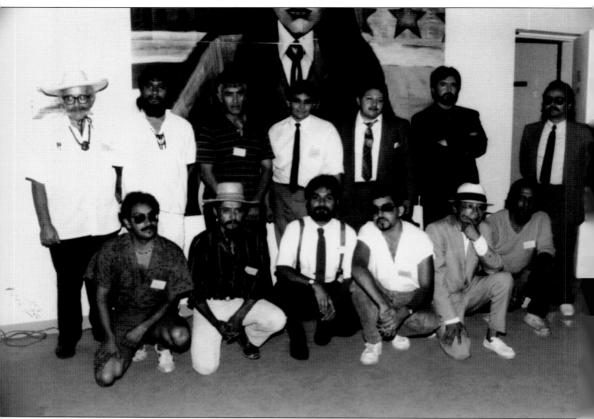

Many of the young artists in this photograph were "fathers" of the modern mural movement in Pilsen. They are, from left to right, (first row) Roman Villarreal, Hector Duarte, Rene Arceo, Roberto Valdez, Marcos Raya, and Benny Ordonez; (second row) Carlos Cortez, Aurelio Diaz, Jose Guerrero, Jaime Longoria, Francisco Mendoza, Alejandro Romero, and Carlos Barrera. (Courtesy of the NMMA.)

Francisco Mendoza has devoted his adult life to the mural movement in Chicago and in other cities in the United States. As a teacher at the Orozco Community Academy in Pilsen, Mendoza works with paint, ceramic tiles, and even plays the trumpet in order to inspire his students to be expressive and artistic. (Courtesy of Francisco Mendoza.)

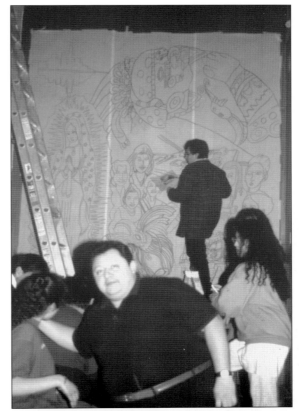

These student artists are completing ceramic artwork on the facade of the Jose Clemente Orozco school complex in Pilsen. They are part of an apprenticeship that may lead to larger public projects for talented artists in the future. (Courtesy of Francisco Mendoza.)

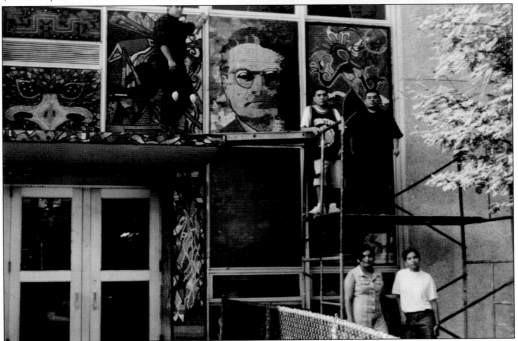

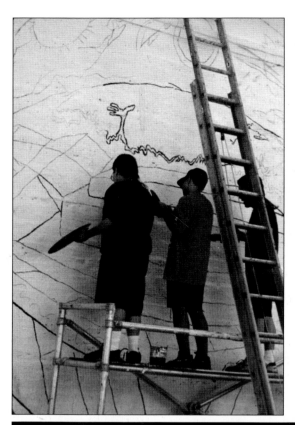

Here young artists are practicing their skills in the art of mural making. They must first prepare the masonry surface and then sketch the subject matter before applying paint. (Courtesy of Francisco Mendoza.)

This mural near Eighteenth Street is bold and colorful but offers mixed messages. The subject is Benito Juarez, one of the most admired and heroic presidents of Mexico. Juarez believed in distributing wealth to the peasants. Ironically, the mural also promotes Coca-Cola, a wealthy multinational corporation. (Photograph by P. N. Pero.)

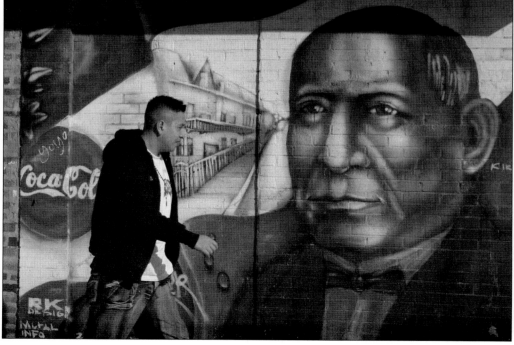

Pilsen has contributed to the literary arts of Chicago. Its gritty urban stories and streetwise poems are typical features of the Chicago School of Literature. Here the neighborhood's revival is celebrated in *Time Out Chicago* magazine. (Courtesy of *Time Out Chicago* magazine.)

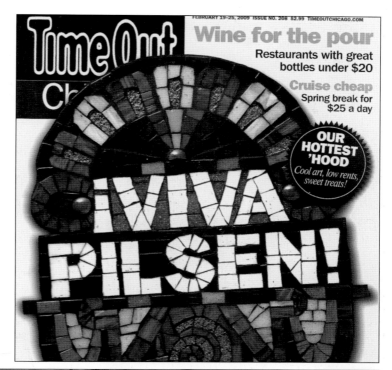

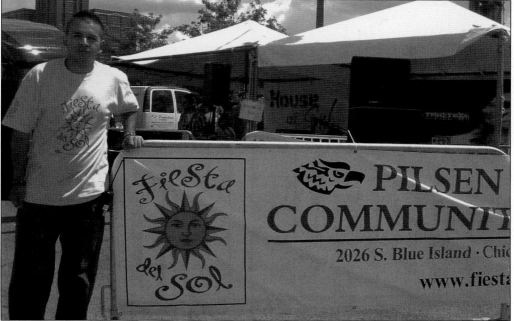

The largest annual festival in Pilsen is the Fiesta del Sol celebration. When it was established in 1973, the fiesta was a small block party event. Today it stretches for about a half mile along Cermak Road and attracts thousands of visitors to the food vendors, educational booths, and local artists at the festival. The weeklong event is an annual fundraiser for the Pilsen Neighbor's Community Council. (Photograph P. N. Pero.)

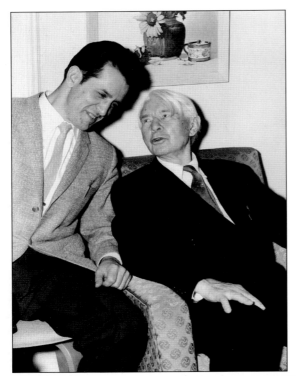

Carl Sandburg (right), who described the "City of the Big Shoulders" and Maxwell Street, was a Pulitzer Prize–winning author and neighborhood explorer. In this rare photograph, Henry Bellagamba interviews Sandburg as poet of the prairie and a favorite son of Illinois. Bellagamba was a radio journalist who frequently reported on Pilsen events. (Courtesy of Aurelio Barrios.)

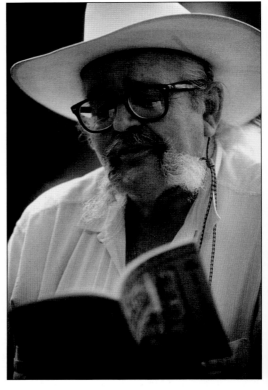

Carlos Cortez was a multitalented legend in Pilsen. He was a graphic artist, poet, and storyteller. His book *Viva Posada* was a poetic tribute to artists during the Mexican Revolution. (Courtesy of the NMMA, Mexican Chicago Archives.)

Shown here is scratchboard art created by Cortez in 1992 for the cover of his book of poems entitled *De Kansas a Califas & Back to Chicago*. (Courtesy of Abrazo Press.)

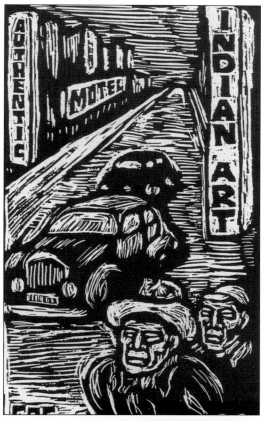

Acclaimed author Stuart Dybek spent part of his childhood in Pilsen and writes about it. Many of his award-winning books describe working-class family life from Pilsen to Lawndale. In his books *Streets in their Own Ink* and *Childhood and Other Neighborhoods*, Dybek recalls a community in transition—from Czech to Polish to Latino. Professor Dybek's novel *Coast of Chicago* was chosen as Book of the Year by Chicago Public Schools. (Courtesy of Stuart Dybek.)

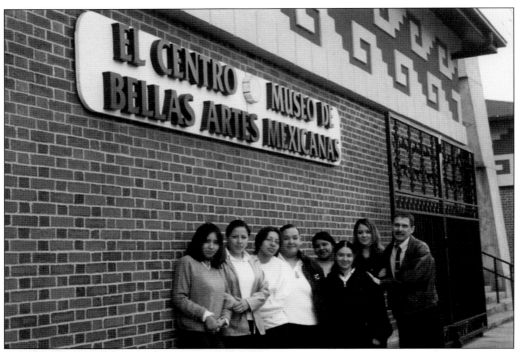

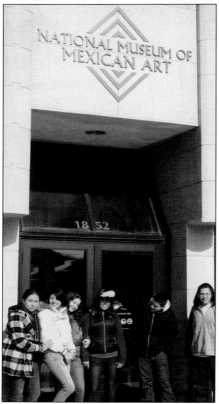

In 1986, the Mexican Fine Arts Museum was born in Pilsen. Museum director Carlos Tortolero brought fresh, new ideas for delivering the arts to Chicago's Near Westside, an area known more for industry than for painting. The museum now draws more than 200,000 patrons per year. Elementary and high school students join art workshops here, and the museum even created a radio station for teens at a satellite site in Pilsen. (Photograph by P. N. Pero.)

By 2006, the museum reinvented itself as the National Museum of Mexican Art (NMMA), the largest Latino arts organization in the United States. The NMMA brings art exhibits of international importance to Chicago. Literary luminaries like Sandra Cisneros and Julia Alvarez have appeared at the museum. As a bonus, the NMMA draws tourists into Pilsen who shop and dine in the community. (Photograph by P. N. Pero.)

Carlos Cortez was a political activist and graphic artist. He spent decades producing poster art in support of political causes. Pictured at the National Museum of Mexican Art are Carlos (in hat) and civil rights leader Cesar Chavez signing a Cortez poster. (Courtesy of Carlos Tortolero and Rita Jirasek.)

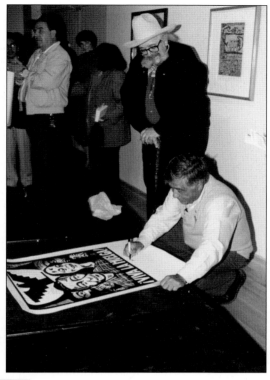

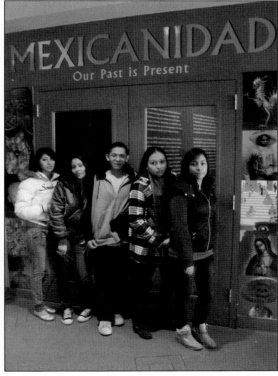

A key objective of the National Museum of Mexican Art is to foster cultural awareness among young immigrants as well as for the public at large. The NMMA believes that young people who know their heritage and understand how to utilize the fine arts become more expressive and creative adults. (Photograph by P. N. Pero.)

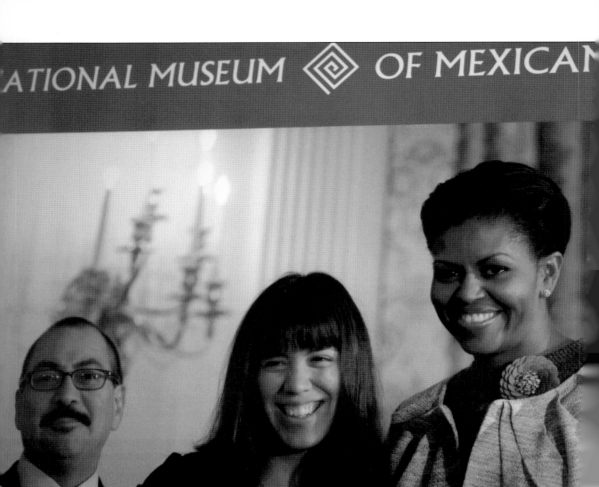

The Yollocalli Youth Museum is a satellite workshop of the National Museum of Mexican Art. Yollocalli perpetuates a plethora of arts from mask making to radio broadcasting in Pilsen. In this picture, Gabriel Villa (left), a youth coordinator for Yollocalli, and member Deborah Garcia (center) get recognition from First Lady Michelle Obama in Washington, D.C. (Courtesy of the NMMA.)

Seven

COMMUNITY ORGANIZATIONS

Pilsen has confronted a history of social problems. For decades, immigrants to this neighborhood faced the challenges of resettlement in a new country and the burdens of finding work and housing.

Tensions and misunderstandings among ethnic and racial groups were inevitable in a tight geographic enclave like Pilsen. But Pilsen has never existed without solutions. The tradition of social services goes back to the late 1800s, when Jane Addams reached out to Pilsen and offered the services of Hull House. Addams was annoyed that the rich families of Chicago sent their young scions to discover foreign cultures in Europe, when more than seven languages were already spoken in Pilsen.

Hull House was not the only settlement house to serve the Westside. Pilsen created settlement houses of its own. Howell House, an Anglo church mission, opened its doors in 1909 to assist with immigrant settlement. The center was used by Czechs, Poles, Lithuanians, Croats, and Slovaks. Today Howell House has been reborn as Casa Aztlan, an active social center for the Mexican community. In 1898, the Gads Hill Settlement House also opened on Cullerton Street. One of its goals was to promote local solutions to teen delinquency in Pilsen.

A unique aspect of Pilsen lies in the ability to heal itself. A tradition of mutual aid and self-help has been the key to the independence of this plucky community. Enterprising Bohemians created the Czech-Slovak Protective Society as soon as they arrived in Pilsen. Later it grew into the Czechoslovak Society of America, the oldest Bohemian fraternal organization in the United States. Social-athletic clubs organized by the Germans, Czechs, Poles, and Mexicans were a common source of ethnic pride and unity. These clubs promoted sporting events, language classes, folkloric dances, and other activities related to homeland traditions.

Today the legacy of the early community organizations still exists in Pilsen. Groups like the Pilsen Neighbors Organization, the Spanish Coalition for Jobs and Housing, the Resurrection Project, and other local groups are examples. More than 21 agencies currently exist in Pilsen to provide care for the community. Moreover, these self-help groups tend to resist commercial and political interference from outside Pilsen. Will this tradition insure Pilsen's identity and survival in the future?

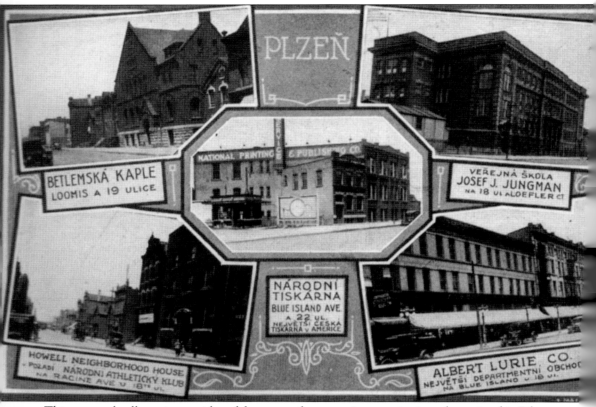

This postcard collage gives an idea of the scope of community organizations that existed in Pilsen. The Jungman School still stands today. The Bethlehem and Howell settlement houses merged resources by 1965, but today all of their facilities have been folded into the Casa Aztlan Center on Racine Avenue. The Albert Lurie company closed decades ago and was never replaced with a major department store. (Courtesy of the Czech Heritage Museum.)

One of the earliest benevolent organizations in Pilsen was the Czech-Slovak Protective Society, which was created in 1879. This building no longer exists, but the idea of mutual benefit societies lives on today through the Czechoslovak Society of America (CSA). This fraternal organization has about 23,000 members and 64 lodges across the country. It is one of the oldest Bohemian fraternal organizations in America. (Courtesy of the Czech Heritage Museum.)

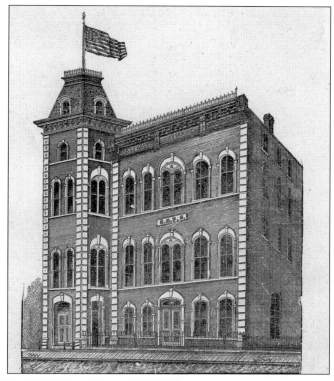

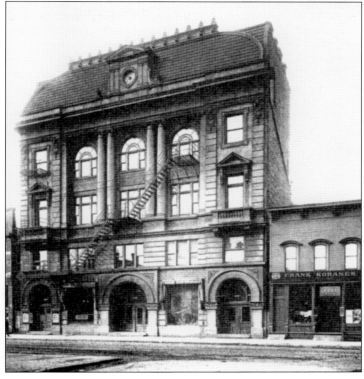

An enormous lodge still stands today at 1436 West Eighteenth Street and is the old Czech-Slavonic American Hall. The hall was constructed through fundraising by several fraternal societies. It was completed in time for the Columbian Exposition of 1893, and Pres. William Howard Taft visited the auditorium. The hall was a haven for conventions, dances, drama, and cultural events. Today it is owned by a Mexican organization dedicated to protecting worker's rights (APO). The spirit of the original founders lives on at the great hall. (Courtesy of the Czech Heritage Museum.)

Hull House was not the only center for immigrants on the Chicago's Westside at the end of the 19th century. In Pilsen, Gads Hill Center opened in 1898. Ruth Austin was a forceful leader who created a high school center for dropouts, English classes for immigrants, and children's exercise classes, which were held on the roof. Austin stayed at the center for 30 years and died at age 105. She was Pilsen's own Jane Addams. (Courtesy of the Chicago Public Library, Special Collections, ghc1-89.)

Chicago settlement houses like Gads Hill offered recreation and exercise that could not be found in the streets and alleys of Chicago. Social reformers believed that physical exercise inspired teamwork, improved public health, and helped youth avoid the undertow of gang activity or sweatshop labor. (Courtesy of the Chicago Public Library, Special Collections, GHCL-122.)

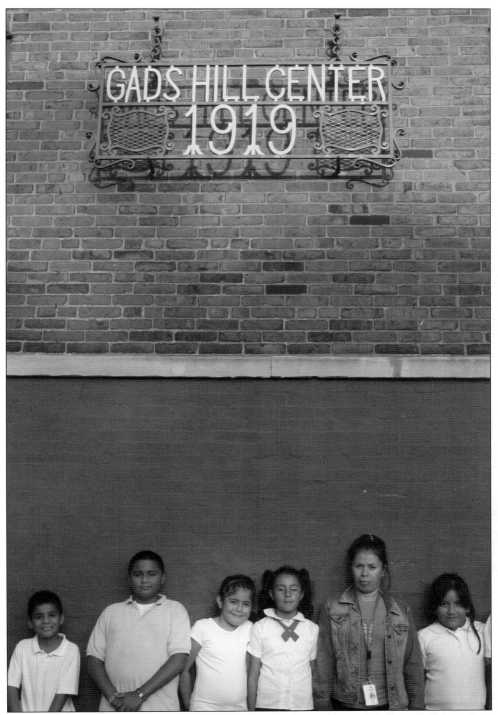

After a century of helping kids, the Gads Hill Center today is alive and well on Cullerton Street. Its formula of combining recreation and schoolwork has spread from Pilsen to the Bridgeport and Lawndale communities. (Courtesy of the Gads Hills Center.)

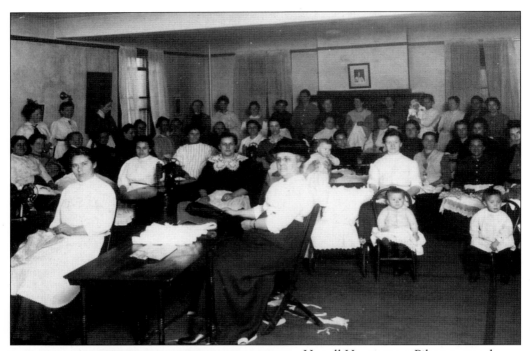

Howell House was a Pilsen outreach center, formed in 1909 by the Presbyterian Church. Howell focused on vocational and educational training as illustrated by this sewing class for women in 1915. There were also English-language classes and book clubs for working adults. Howell and a religious partner, the Bethlehem House, sponsored children's summer camps in Michigan. It was a chance for immigrant children to enjoy fresh air and a taste of the countryside. (Courtesy of Paul Nemecek.)

By 1965, Howell House could no longer sustain its original mission and passed on its buildings at 1831 South Racine Street to Casa Aztlan, an organization in tune with the needs of the Mexican community. This photograph shows some murals that completely cover the building; they are among the oldest in Pilsen. (Photograph by P. N. Pero.)

A prominent leader in American history as well as a source of pride for Mexican Americans is Cesar Chavez. During the civil rights struggle for African Americans in the 1960s, Chavez expanded the movement to include Latino people. He visited Chicago in 1966 to speak at the J & L Steel Company; later that day he visited Casa Aztlan. (Courtesy of Aurelio Barrios.)

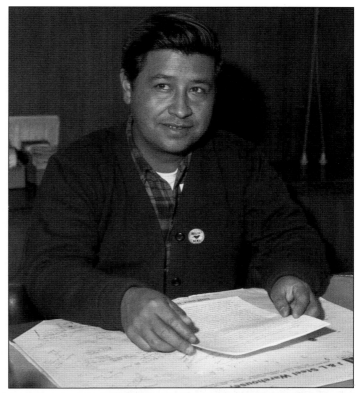

The lifetime goals of Cesar Chavez are still celebrated in the streets of Pilsen. His focus was on the conditions of agricultural workers in America, but Chavez also championed the right of all workers to form trade unions. (Courtesy of Antonio Perez.)

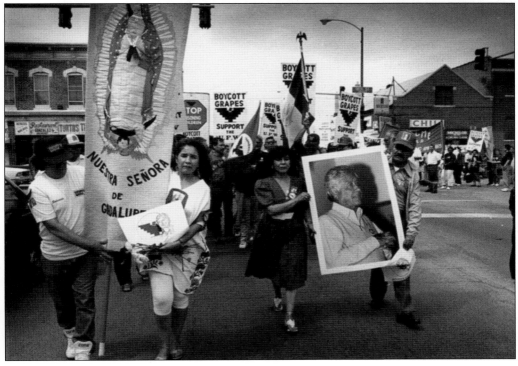

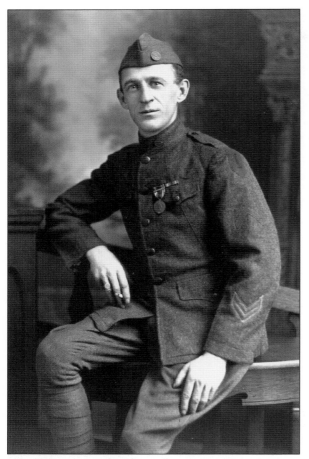

Many Pilsen residents are veterans of American wars around the world. As early as World War I, soldiers from Pilsen marched home in uniform. This decorated doughboy, Jack Kohout, is presented in a 1917 studio portrait. (Courtesy of Paul Nemecek.)

Manuel Perez earned the Medal of Honor for his bravery and ultimate sacrifice during World War II. In his name, an American Legion post for Pilsen was organized in 1947. Shown in this photograph are many of the veterans gathered in 1972 for the 25th reunion of the local legion post. (Courtesy of Aurelio Barrios.)

Many women gave their support to the military and to veterans from Pilsen. In this 1950s photograph of the women's auxiliary of the American Legion post, new recruits pledge their support. (Courtesy of Aurelio Barrios.)

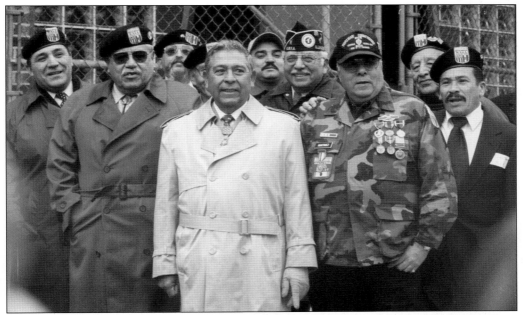

Veterans in Pilsen are very active and organized. In this ceremony, a Medal of Honor winner is flanked by local veterans of the Second World, Korean, and Vietnam Wars and other military conflicts. Pilsen veterans each year memorialize the soldiers who gave their lives during wars overseas. (Photograph by Antonio Perez.)

A rich resource for books and learning in Pilsen is the Rudy Lozano branch of the Chicago Public Library. It opened in 1989 at one of the busiest pedestrian intersections in Pilsen. Pre-Columbian Olmec motifs are integral to the decor inside the library. (Photograph by P. N. Pero.)

Students in Pilsen rely on the Lozano Library as a vital resource. Here two students from Juarez High School search for new books. For many residents, young and old, the Lozano Library is their portal to the Internet. (Photograph by P. N. Pero.)

A noted tradition at Lozano is the library chess tournaments. The chess club was formed in the 1990s by Hector Hernandez, now the library branch manager. Young people have earned statewide honors and awards by joining this successful after-school program at Lozano. (Courtesy of Hector Hernandez.)

The Lozano Library has a children's meeting room, auditorium, and adult meeting rooms for free use by patrons. It once had a tropical tree growing in the center of the atrium. This facility could stay active 24 hours a day—if the City of Chicago could afford it. (Courtesy of Hector Hernandez.)

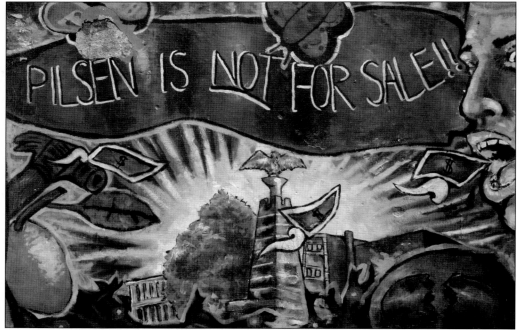

An issue that is vital to Pilsen's future is the fight over real estate development. Longtime residents are opposed to development projects that would force up prices and rent in Pilsen. Although the entire community of Pilsen has been designated an official historic district, new condominium development continues. (Photograph by P. N. Pero.)

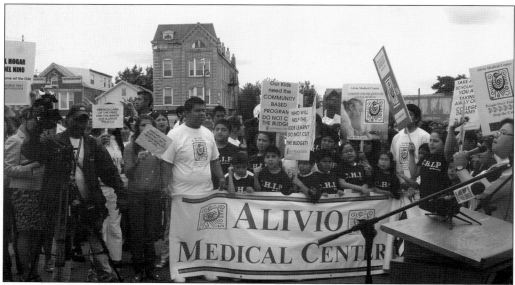

The Alivio Health Clinic is a homegrown medical center in Pilsen. Created in 1988 by Mercy Hospital and funded by corporate donations, Alivio serves thousands of immigrants who cannot afford to receive full-scale medical care. When funds are cut for Alivio, many people in Pilsen rally to help as shown in this photograph. (Courtesy of the Heriberto Quiroz.)

Rudy Lozano was a rising star on the Chicago political horizon during the 1980s. He was a labor union organizer and social activist in Pilsen. Allied with the late Chicago mayor Harold Washington, Lozano was a key voice for the city's Mexican community. (Courtesy of Hector Hernandez.)

In 1983, Rudy Lozano was shot dead in his Pilsen home by a hired assassin. The city mourned and named the Pilsen public library in his honor. (Courtesy of *Chicago Reader*.)

This Issue in Three Sections

ЯEADER.

Friday, April 26, 1985 Volume 14, No. 30 CHICAGO'S FREE WEEKLY

Who Killed Rudy Lozano?

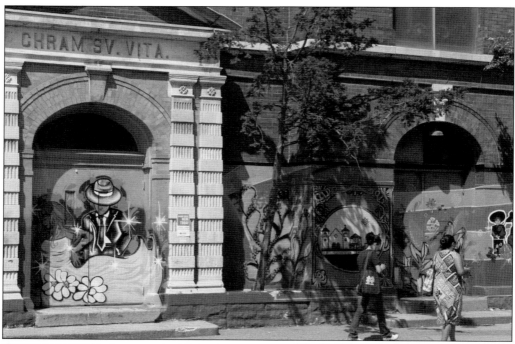

The Resurrection Project was created in 1990 by a coalition that used the old St. Vitus Church building as a housing incubator and child care center. Colorful murals were painted by Pilsen student workers under the direction of artist Hiram Villa. (Courtesy of Hiram Villa.)

A success story for Pilsen has been the Resurrection Project, which involved neighborhood organizations bound together to build affordable homes for first-time family buyers who meet income guidelines. Here the Alba family poses in front of their first home on Eighteenth Place near Western Avenue. (Photograph by P. N. Pero.)

Eight

STREET LIFE

In some respects, what happens on the streets of Pilsen is as important as what goes on behind closed doors. There are holiday parades, political demonstrations, and religious pageants that bring publicity and notoriety to the neighborhood.

Nearly every place is walkable in Pilsen. There are plenty of corner grocers, tailors, shoe repair shops, hardware stores, and enterprises that have nearly disappeared in the car-crazed suburbs of Chicago. The streets of Pilsen also serve as a social stage for lovers, bikers, musicians, brawlers, and residents who enjoy strolling and socializing on front porches and street corners.

There is auto traffic that adds to the density of Pilsen. Trucks seem to exist everywhere, as do small cars packed with large families. Customized "lowrider" vehicles cruise the back alleys of Pilsen, where car culture becomes urban legend.

No resident walks very far in Pilsen without finding mass transit. The Chicago Transit Authority (CTA) has a station on Paulina Street distinctively decorated with Mexican ceramics. Another station on Damen Avenue is decorated with murals. During the 1930s, the old Douglas Park CTA line from Pilsen to Lawndale was called the "Bohemian Zephyr" because of the many Czech commuters who patronized this train.

The parks in Pilsen have a long and colorful history. Jens Jensen was the designer of Dvorak Park in 1908. He tangled with Chicago's chief city planner, Daniel Burnham, over what a public park should look like. Jensen wanted plenty of amenities for the neighborhood residents, but Burnham wanted to construct more formal showcase parks that would attract worldwide attention. In designing Dvorak Park, Humboldt Park, Douglas Park, and Garfield Park in Chicago, Jensen compromised with Burnham. With these four historic spaces, he provided plenty of greenery but also added field houses, sports fields, and boating areas to serve the local citizens. (Details on Dvorak Park can be found in this chapter.)

Pilsen's second-most popular green space is Harrison Park. It was constructed in 1912 and attracted social reformers who believed that urban parks were living laboratories of "progressivism." According to author Alan Mammoser, even playground supervisors during Chicago's reform era enrolled in academic training that included storytelling, psychology, folk dancing, and choral singing.

Today thousands of visitors are discovering the colorful fabric of Pilsen. If they do not buy a single piece of merchandise, there is still a richness to discover in simply observing the street life of the community. This chapter offers photographic evidence.

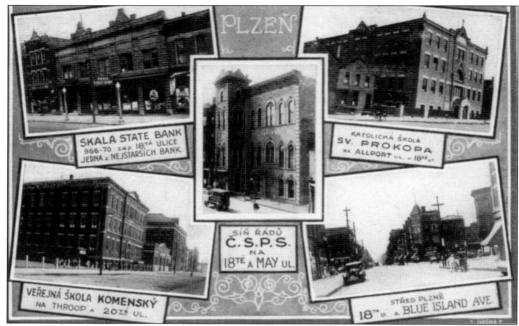

The streets of Pilsen are a stage for playing out the commercial and residential life of the neighborhood. This postcard collage by photographer Ernst Macha shows a cross-section of street life. The card features Pilsen landmarks that include a bank, church, school, and public meeting hall, all located within five square blocks in this compact community. (Courtesy of the Czech Heritage Museum.)

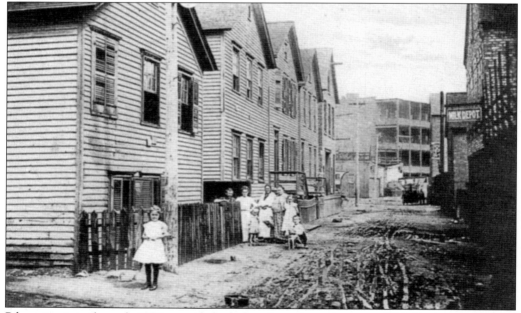

Pilsen streets in the early 1900s provided a dark and unruly environment. This block called "Czech Alley" at Throop and Eighteenth Streets offered a rutted muddy street, no trees or greenery, and few parks or playgrounds for miles. (Courtesy of Thomas Capek, *The Czechs in America*.)

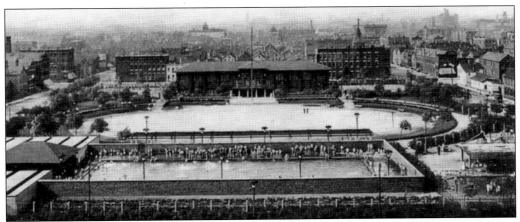

The first public park to offer recreation and green space in Pilsen was Dvorak Park on Cullerton Street. Jens Jensen artfully planned the park, and it opened in 1908 with a pool that could accommodate 1,700 swimmers per day and a field house that offered a library and meeting rooms. The field house was built in the Prairie style, a design that Chicago architects contributed to the world of architecture. (Courtesy of the Library of Congress.)

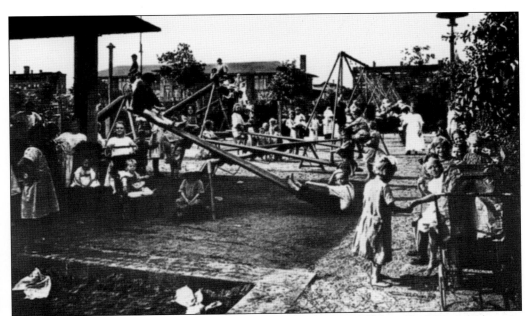

Public playgrounds were laboratories for social reformers like Jane Addams. She believed "the state might cultivate democratic values through organized play." At the very least, immigrant children in Pilsen learned about American sports, found alternatives to sweatshop labor, and escaped from crowded and polluted streets. Dvorak Park was named after the Czech composer and conductor Antonin Dvorak who visited Chicago in 1893 for the Columbian Exposition. (Courtesy of the Library of Congress.)

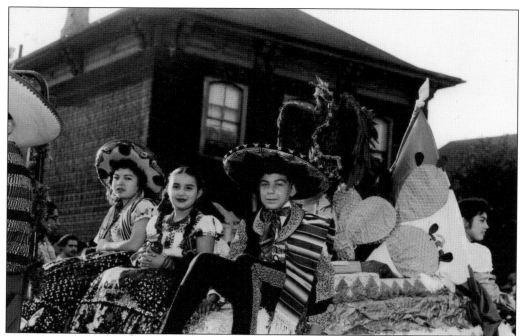

Children have always been an important part of the Pilsen street scene. Whether writing with chalk on sidewalks, playing street games, or dressing up for a formal parade, the kids of Pilsen help soften the hard edges of city life. (Courtesy of Aurelio Barrios.)

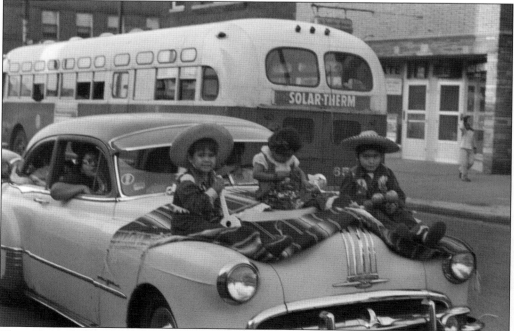

These three children and their parents chose to create their own viewing stand for the Mexican Independence Day Parade in 1959 by sitting on blankets that cover the hood of the family car. (Courtesy of Aurelio Barrios.)

Through all kinds of weather, Pilsen residents are accustomed to outdoor commerce. Many Pilsen residents have imported the tradition of open-air markets from their homelands. Ice cream delights, exotic drinks, nearly any food that can be carried, and all sorts of dry goods are sold on Pilsen streets. This photograph of a vendor's cart dates back to 1959. (Courtesy of Aurelio Barrios.)

A fashion tradition in Pilsen is to promenade in and around Eighteenth Street. These companions show off their street wear in 1962. According to the photographer, all three of these young men later found careers beyond Pilsen in the clothing, insurance, and music industries. (Photograph by Aurelio Barrios.)

Bicycles have been a popular mode of transportation for decades in Pilsen. Here a family shows off a new airstream design more than 50 years ago. With the cost of gasoline and heavy auto traffic today, bike travel is surging in Pilsen. Irv's Bike Shop at Racine Avenue and Eighteenth Street is a service hub for hundreds of bikers and has thrived on that corner since 1963. (Courtesy of Aurelio Barrios.)

Pilsen has other modes of mass transportation. There are three Chicago Transit Authority city train stations available, a Metra station that links Pilsen to the far western suburbs, and even an international bus pickup point on Ashland Avenue. It is possible to buy a bus ticket from Pilsen to Mexico City for less than $200; the trip takes 42 hours. (Photograph by P. N. Pero.)

The demolition of these silos on Lumber Street marked the end of an era in East Pilsen. The area was a hub of activity related to the storage and shipping of grain and lumber. With a changing economy, these silos outlived their use by 1965. (Courtesy of the UIC Library, 59892.)

By 1900, most of Pilsen raised its streets to make room for new city sewer and plumbing systems. This caused sidewalks and entire houses to be elevated as much as 10 feet to meet the new street level. Working-class homeowners who could not afford to raise their cottages constructed bridge-like stairways to the second floor and added a new front door. Essentially this brought visitors into bedrooms until a second-story living room or foyer could be constructed. Moats of concrete, like the one in this photograph, give Pilsen a precarious architectural character. (Photograph by B. Seo.)

This iron gate greets visitors to Eighteenth Street. Pilsen has no grand gateway like the stucco archway over Twenty-sixth Street in the Little Village community, but this also means Pilsen has fewer traffic bottlenecks. The neighborhood has plenty of entryways via Blue Island Avenue, Cermak Road, Ashland Avenue, and a number of mass-transit stations. (Photograph by Heriberto Quiroz.)

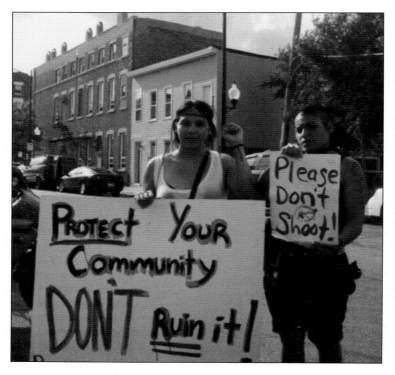

Pilsen youth are concerned about gun violence in the community, as are their parents. Here a local rally earns strong grassroots support in the neighborhood. (Photograph by Heriberto Quiroz.)

In 2007, a large protest occurred in Chicago to support the reform of immigration laws in America. Marchers rallied at Cermak Road and Ashland Avenue in Pilsen before walking to the Federal Plaza in downtown Chicago. Hundreds of students joined the immigration march in the Loop. This young onlooker, draped in the American flag, watches the rally in support of justice for immigrants. (Courtesy of Heriberto Quiroz.)

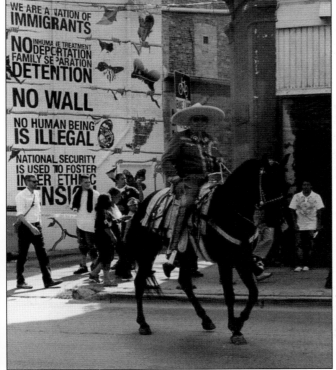

The caballero (cowboy) in this parade on Eighteenth Street is Remberto Del Real, who shows off his horse and Mexican regalia. The mural behind him presents a backdrop of fear and anger over federal immigration laws that create unrest on the streets of Pilsen. (Photograph by Aurelio Barrios.)

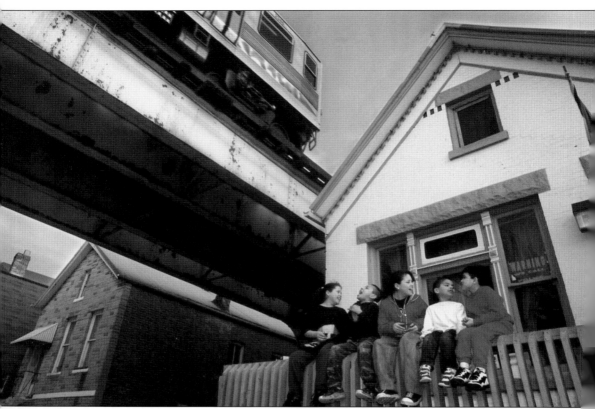

Pilsen youth are resilient, street smart, and accustomed to traffic. Despite the noise of a commuter train just above their home, these kids seem oblivious to the commotion. (Courtesy of Antonio Perez.)

BIBLIOGRAPHY

Adelman, William J. *Pilsen and the West Side*. Chicago: Illinois Labor History Society, 1983.

Capek, Thomas. *The Czechs in America*. New York: Houghton Mifflin, 1920.

Chicago Fact Book Consortium. *Local Community Fact Book: Chicago Metropolitan Area*. Chicago: University of Illinois Press, 1995.

Cortez, Carlos. *De Kansas a Califas & Back to Chicago*. Chicago: March/Abrazo Press, 1992.

Cutler, Irving. *Chicago, Metropolis of the Mid-Continent*. Carbondale, IL: Southern Illinois University Press, 2006.

D'Amato, Paul. *Barrios*. Chicago: University of Chicago Press, 2006.

Farr, Marcia. *Rancheros in Chicagoacan: Language and Identity in a Transnational Community*. Austin, TX: University of Texas Press, 2006.

Fremon, Dave. "Recall days when Pilsen workers were near revolt." *Lawndale News/Westside Times*, February 2, 1984.

Grossman, James R., Ann Durkin Keating, and Janice L. Reiff, eds. *The Encyclopedia of Chicago*. Chicago: University of Chicago Press, 2004.

Hunter, Jennifer. "Sleuthing for clues to Pilsen's Bohemian past." *Chicago Sun-Times*, May 25, 2005, 71.

Jirasek, Rita Arias, and Carlos Tortolero. *Mexican Chicago*. Chicago: Arcadia Publishing, 2001.

Kerr, Louise A. N. *The Mexicans in Chicago*. 1999. Retrieved June 28, 2008, from www.lib.niu.edu/1999/iht629962.html

Pero, Peter. *Chicago Italians at Work*. Charleston, SC: Arcadia Publishing, 2009.

Pilsen Mosaics. Chicago: Exelon Corporation, 2003.

Pugh, Ralph. "Pilsen/Little Village." *Chicago History Magazine,* 26(1), 40–61.

St. Procopius Church. *The First One Hundred Years*. Chicago: Monarch Printing, 1975.

Sternstein, Malynne. *Czechs in Chicagoland*. Charleston, SC: Arcadia Publishing, 2008.

www.arcadiapublishing.com

Discover books about the town where you grew up, the cities where your friends and families live, the town where your parents met, or even that retirement spot you've been dreaming about. Our Web site provides history lovers with exclusive deals, advanced notification about new titles, e-mail alerts of author events, and much more.

MADE IN THE

Arcadia Publishing, the leading local history publisher in the United States, is committed to making history accessible and meaningful through publishing books that celebrate and preserve the heritage of America's people and places. Consistent with our mission to preserve history on a local level, this book was printed in South Carolina on American-made paper and manufactured entirely in the United States.

This book carries the accredited Forest Stewardship Council (FSC) label and is printed on 100 percent FSC-certified paper. Products carrying the FSC label are independently certified to assure consumers that they come from forests that are managed to meet the social, economic, and ecological needs of present and future generations.

FSC
Mixed Sources
Product group from well-managed forests and other controlled sources

Cert no. SW-COC-001530
www.fsc.org
© 1996 Forest Stewardship Council

Find Your Place in History.